SECRET
TRENTHAM

Alan Myatt

AMBERLEY

Acknowledgements

I must give thanks to my wife Glynis for her patience, support and encouragement during my many hours of research.

As far as I am aware the images used are copyright-free. If this is not the case I apologise and will look to rectify the situation.

First published 2018

Amberley Publishing
The Hill, Stroud
Gloucestershire, GL5 4EP

www.amberley-books.com

Copyright © Alan Myatt, 2018

The right of Alan Myatt to be identified as the
Author of this work has been asserted in accordance
with the Copyrights, Designs and Patents Act 1988.

ISBN 978 1 4456 7897 9 (print)
ISBN 978 1 4456 7898 6 (ebook)

British Library Cataloguing in Publication Data.
A catalogue record for this book is available from the
British Library.

Origination by Amberley Publishing.
Printed in Great Britain.

Contents

Introduction 4

1. Vignettes of People's Lives 6

2. Leisure 30

3. Community 48

4. Work 60

5. The Law 70

6. Hard Times in the Victorian Era 84

Introduction

Why write a book about the secrets of Trentham and Dresden? Perhaps this book will go some way to answering those questions that you never asked. To whet your appetite: did you know that the Hutchinson River, which runs through the Bronx area of New York, is named after a family whose ancestors became a dynasty of vicars at Blurton for over 100 years?

Most of the stories within this book are from local newspapers and have had many hours of research. Tribute must be paid to the reporters of yesteryear who meticulously recorded these events.

Secrets of Trentham and Dresden

Trentham and Dresden may seem like strange bedfellows. Trentham was a quaint village community where every cottager paid rent and homage to their lord and master the Duke of Sutherland in his magnificent ducal palace of Trentham Hall. He charged peppercorn rent in exchange for loyalty. He was willing to listen to villagers via his land agent and employ many people as gardeners or servants at the hall. Trentham's history is ancient: Bronze Age weapons have been found in the vicinity of the hall, and a burial mound sits on the high ground overlooking the River Trent at Northwood. Werburgh founded a nunnery where the three rivers meet, which was later converted into a Benedictine monastery. It was never prosperous, but was nevertheless coveted by Henry VIII and became one of his victims during the Dissolution of the Monasteries. Only the priory church was left alone, which was because it was also the parish church of the villagers. Shortly after, the ruins were purchased by a wealthy wool merchant from Wolverhampton named Leveson, whose family remained at Trentham for over 300 years and at one time were the wealthiest in the land. They progressed up the social ladder until they became Dukes of Sutherland, and came within a whisker of becoming part of the royal family. Their land stretched over many hundreds of acres, most of which formed the parish of Trentham.

Dresden, on the other hand, was completely different. There were no quaint cottages here with blossoming gardens. Dresden did not even exist until 1851, when streets were laid out in a gridiron pattern by the Longton Freehold Land Society. They had triumphed in purchasing 27 acres of Spratslade Farm from Sir Thomas Boughey of Aqualate Hall in Shropshire for the price of £5,000. Unlike Trentham, it was laid out in straight lines of terraced houses with several large villas for the well-to-do, right on the edge of the countryside, which housed pottery workers and shopkeepers. The best plots on the high

ground were gobbled up by the pot-bank owners as they could see across the valley to observe their smoking bottle ovens. Some factory owners built whole rows of terraced houses for their workers close by their mansions.

The success of this estate prompted the Duke of Sutherland to build his own estate on the other side of the valley, which he named Florence after his favourite daughter. He also opened a colliery, which was also named Florence after her. Unlike Dresden, the duke did not permit any public houses to be erected at Florence. He donated a 45-acre piece of agricultural land to the people of the area, on which the Queen's Park was built.

The parish of Trentham was huge and in 1831 part of it was separated from the parish of Blurton. Dresden was built in Blurton parish but the tiny church was unable to cope with the influx of strangers. It was agreed in 1867 to form a separate parish for Dresden, and the duke donated land at Red Bank for a new church.

1. Vignettes of People's Lives

The funeral of Elizabeth I was led by bell-ringers and knight marshals, who cleared the way with their gold staves. First came 260 poor women dressed in black with white kerchiefs on their heads. Then came the lower ranking servants of the royal household and nobles. Next were two of the queen's horses, riderless and draped in black cloth.

After this came the queen's chariot, which carried the hearse draped in purple velvet and pulled by four horses trimmed in black. On top of the coffin was an effigy of Elizabeth, which was covered by a canopy held aloft by six earls and featured twelve embroidered banners that traced the queen's ancestry. A riderless horse followed behind led by the queen's master of the horse. At the rear walked Sir Walter Raleigh and the guard walking five abreast.

The six Knights of the Canopy were Sir Moyle Finch (1550–1614) of Eastwell, Kent; Sir John Pointon (1544–1630) of Norfolk; Sir Edward Hoby (1560–1617) of Bisham, Berkshire;

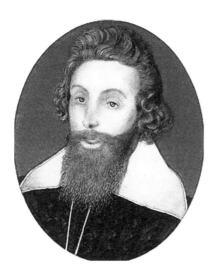

Sir Richard Leveson.

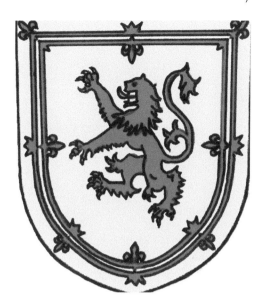

Right: Sutherland coat of arms, complete with double tressure.

Below: Elizabeth I's funeral.

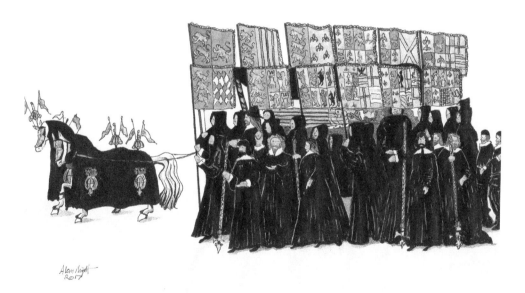

Sir Richard Berkley (1531–1604) of Stoke Gifford; Sir Jerome Bowes of Elford, Staffordshire, who died in 1616; and last but not least was Sir Richard Leveson (1570–1605) of Trentham and Lilleshall, who had an affair with Mary Fitton of Gawsworth, Cheshire. Sir Richard died at a friend's house in St Clement's, London, of the fever, made worse by constant diarrhoea. His body was embalmed and buried at St Peter's Church, Wolverhampton, in 1605.

A large memorial of him standing in his admiral's uniform was hidden away at Lilleshall during the English Civil War, but then part of it was returned to St Peter's at the

Restoration of the monarchy. A copy was made and it stands in the niche of the bell tower at Trentham's old stable yard.

The Sutherland coat of arms includes the rampant Scottish lion enclosed within a double tressure. This denotes descent from royalty but was mistakenly awarded by a confused memory of the family tree by George I in 1719. William, 3rd Earl of Sutherland, was a follower of Robert the Bruce. The 4th Earl died fighting the English in 1333, and his son William, the 5th Earl, married the king's sister Margaret Bruce. However, it is now clear that the later Earls of Sutherland were not descended from William and Margaret, so are not entitled to use the double tressure.

DID YOU KNOW?

The Marquis of Stafford came into possession of Queen Marie Antoinette's jewels in 1792, and that they were fashioned into a necklace to be worn by Anne Hay-Mackenzie on her wedding to the 4th Marquis of Stafford on 20 June 1849. The jewels were given to Countess Elizabeth Sutherland by the French queen in 1792. The Staffords were friendly with the queen and supplied her with clean clothes and other contraband during her incarceration. Marie Antoinette handed the countess two small bags, one containing pearls and the other containing diamonds, which she concealed beneath her garments. Lord and Lady Stafford were at great risk of being arrested despite their diplomatic immunity as ambassadors to Paris. The French queen lost her head on the guillotine the following year in 1793. The necklace containing the diamonds and pearls was offered for sale in 2007 with an estimated price of £350,000 to £400,000, but they remained unsold.

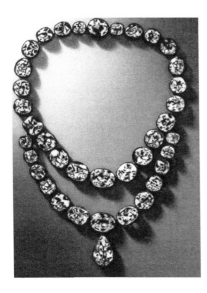

Ageless diamonds.

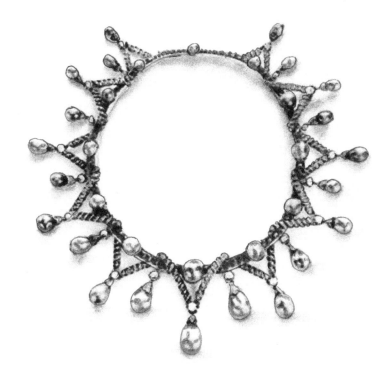

Right: The Sutherland necklace, made from pearls belonging to Marie Antoinette.

Below: Stafford House.

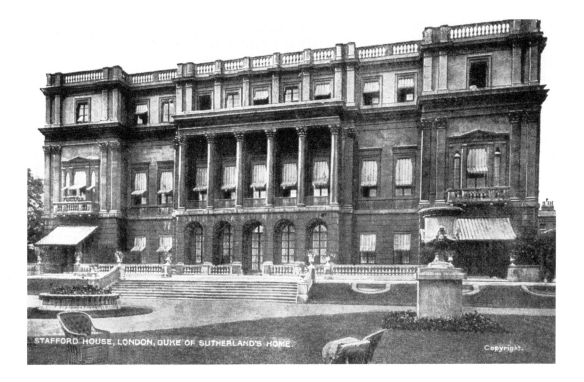

STAFFORD HOUSE, LONDON, DUKE OF SUTHERLAND'S HOME.

Granville Leveson-Gower, 1st Duke of Sutherland, was born in 1758. He was a dull nervous man who had a beaky nose, a prim mouth, poor eyesight in later life, and was rather shy. He had the unusual ability to fall asleep if kept waiting at meetings, waking up ready for action. He was fluent in French and was appointed the British ambassador to Paris in 1790. He was rewarded with a dukedom for his diplomatic services. He was advised by his doctor to refrain from intercourse with his wife due to his poor health. Unfortunately, she fell pregnant during this time with Lord Francis, who became 1st Earl Ellesmere. It was the descendants of Lord Francis who would ultimately become the 6th and 7th Dukes of Sutherland when the 5th Duke died without an heir.

It was Granville who had the Egyptian-style mausoleum built at Trentham in 1808 for himself. He died in 1833 shortly after being made a duke but was not buried at Trentham, instead being laid to rest beneath the floor of Dornoch Cathedral. His son George was born in 1786 and took little interest in politics because he was hard of hearing. He did the usual grand tour of Europe as part of his education and fell head over heels in love with Princess Louise of Prussia. He was left broken-hearted as she was betrothed to Prince Regent Frederick. George vowed never to marry after this, but had a torrid affair with Napoleon's sister Pauline. George was to eventually marry his cousin Harriet Howard and he became the 2nd Duke of Sutherland. Harriet was an avid house builder and the duke's fortune dwindled dangerously low, leading to furious rows. He died in 1861 and was the first duke to be laid in the catacombs at Trentham mausoleum; Duchess Harriet joined him in 1868.

Their son William was born in 1828 and became very ill as a youngster. His mother nursed him back to health at Uppat House, Dunrobin. He took little interest in his estates and preferred tinkering with machinery. Queen Victoria accused him of leading Bertie astray. They were both founder members of the Four in Hand Driving Club in 1856, who met at Piccadilly. This organisation was the first to ditch the cravat in favour of the necktie and created the four-in-hand knot still in use today. William married Anne Hay-Mackenzie, Countess of Cromartie, but treated her badly, having an affair with the wife of one of his estate workers, shocking Victorian society. The humiliated duchess spent most of her time away from Trentham. She was buried in the local cemetery at Torquay. The duke then married his mistress, and when he died in 1892 he was buried in the earth at the Trentham mausoleum. When his new duchess died she was interred with him. Mary Caroline Blair caused a huge rift in the family and depleted the family fortune considerably.

The Duke of Sutherland's Florida Home
Acording to the *Sentinel* in 1889:

> Sutherland Manor, the only permanent ducal residence in the United States, is situated on an eminence overlooking the picturesque region of Butler Lake.
>
> It is around 2 miles east of the village of Tarpon Springs. Approaching the duke's villa, you pass through orange groves and forests of pine, intercepted here and there by clumps of funeral cypress loaded with festoons of grey moss. There are also patches of scrub palmetto trees, and in the dark pools of the forest are innumerable Florida reptiles, but the old-time supply of alligators is diminished due to the frequent raids hunters

and their repeating rifles. Above the low ground on the plateau the scene is beautiful. On a sloping terrace overlooking the lake are several raised flower beds, which are kept from washing away by rows of inverted bottles. Young orange trees follow the northern slope until they reach the banana walk on the low ground near the lake. There is an indescribable charm about the place; a peaceful luxurious atmosphere fragrant with balsamic odours from the pines and orange groves. Narrow walks winding amid citrus and evergreen oaks lead down to the lake where the duke's boats skim the sparkling waters like birds. This 40-acre tract of beauty, situation and health is one of the finest in Florida.

Their large commodious house was provided with all the convenience of the best American home. The servants comprised a French chef, a black assistant, a black general worker, the duke's valet, and the faithful English butler John Potter, who served his employer for twenty years in various capacities. He was the first to rise in the morning, and he and the valet prepared the dining room for the morning meal – female servants of the right sort were exceedingly difficult to procure in that part of the world. American guests were surprised and delighted at the excellent service down there in the wilderness. With noiseless celerity, the butler and the valet waited on the table and served the courses.

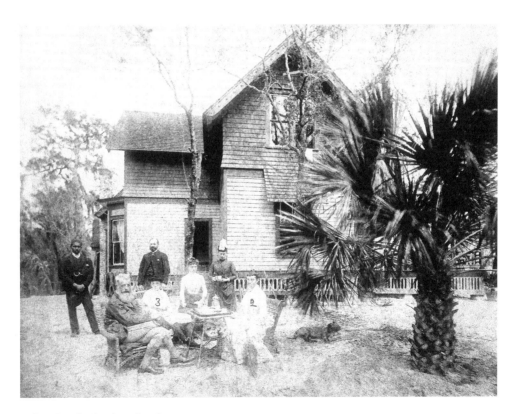

Duke of Sutherland in Florida.

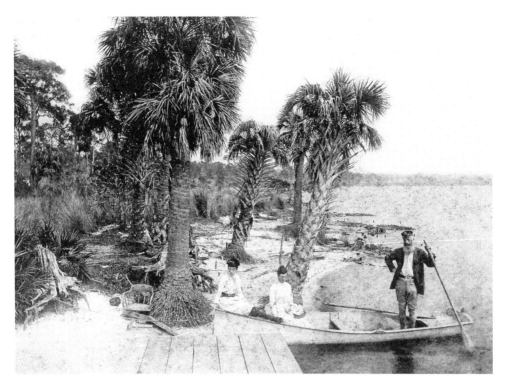

Duke of Sutherland in Florida.

Summer Visits in England

It was announced just before the duke and his family sailed for England that a portion of the summer would be spent at Dunrobin Castle. A pleasant incident of the summer was a meeting of the brothers of the duchess at her beautiful home in Trentham. They were unusually tall men, the smallest being over 6 feet in height. The duke's Florida residence was placed in charge of a keeper until they returned in the autumn.

Arrival of the Duke of Sutherland at Trentham

Saturday 18 May 1889. The Duke and Duchess of Sutherland arrived at Trentham last evening on their return from Florida. This fact becoming known, a large crowd of about 100 people were attracted to the pretty village to witness their grace's arrival. The train was stopped at Trentham station, where a Stanhope Phaeton drawn by two spirited cobs, and a coach with a pair of black horses attached, awaited the arrival of the Duke and Duchess. The Duchess at once took her seat in the Phaeton, quickly followed by the Duke and immediately drove to the Hall with the Duke driving. Cheers were called for and given, which were graciously acknowledged. The coach was occupied by several servants and Miss Blair, daughter of the Duchess.

At present, there are no visitors to the Hall, but in a few days the house party will number twenty-three, the majority of whom will be relatives of the Duchess. The Duke and Duchess will remain at Trentham Hall for ten days.

Peter Christie Blair, Last Head Gardener at Trentham

Peter Christie Blair was born at Largo, Fife, in Scotland, on 29 May 1854. Largo was famed as the birthplace of a young man who went to sea named Alexander Selkirk, who was abandoned on an island at his own request and inspired the book Robinson Crusoe. Peter Christie left for London to train as a gardener at the famous Veitch Nurseries in Chelsea. He went to live in lodgings at No. 543 Kings Road, Fulham, with his wife Margaretta, who was born at Westminster, and his son Alexander James, who was born in 1879. They had a daughter named Ethel Mary in 1885, but Margaretta died shortly afterwards. Peter Christie came to work at Trentham and started to court Charlotte Theresa Holt, who was the daughter of the head keeper at Lilleshall Hall in Shropshire. They were married on 30 April 1889. After breakfast, the happy couple left for London en route for Paris.

Peter became head gardener of Trentham after the death of Zadok Stevens in 1886 and moved from the village into the head gardener's house in the gardens, with his wife Charlotte and son Alexander James from his first marriage, and his daughter Ethel Mary aged six in 1891.

His daughter from his second marriage was Laelia Dorothy, who was born at Trentham in 1890. Another son, George Peter, was born in 1892 and daughter Doris was born in 1897.

Havergal Brian was a musical composer from Dresden who went to live at Trentham, and in 1910 he writes about Peter Blair living among the glasshouse ruins at Trentham Hall. During the Boer War over seventy gardeners were dismissed from Trentham. Blair was a tall figure of genial countenance, known as the grand old man of Trentham.

Peter Christie Blair passed away at his home on 23 October 1936, in his eighty-second year. The service was held at Trentham Church, followed by interment in Trentham Mausoleum grounds. Wreaths were sent by the Duke and Duchess of Sutherland, the Marchioness of Londonderry and Viscount Chaplain. He left a widow, two sons and three daughters. He was the last person to hold the title of 'Head Gardener of Trentham Hall'.

Peter Blair.

Robinson Crusoe.

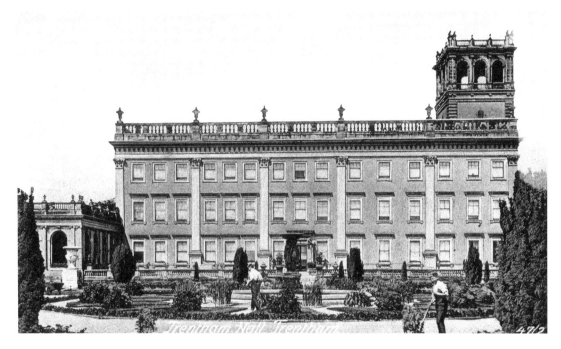

Gardeners.

Trentham' Tallest Man

Richard Brough was born on 14 February 1786 in Trentham. As a young man, he learned the trade of carpentry and brickmaking at one of the many brickworks in the area.

When he was aged nineteen he joined the Army as a private and signed up for seventeen years and 184 days. He was in the 8th Battalion Royal Artillery, described as a tall man for that period (5ft 11 inches in height) with a brown complexion, brown hair and grey eyes. He enlisted on 10 September 1805 at Newcastle-under-Lyme. He sailed for Sicily on 13 September. Landing at Messina, the company sailed for the Bay of Naples on 11 June 1809. The battalion embarked for Zante on 23 September and stayed there for the remainder of the year.

The whole battalion set sail again in July 1812 for Spain, mustering on board a ship at Palomas Bay. They sailed for Genoa in Italy, remaining there until the year of Napoleon's defeat in 1815. On 19 September 1822, they embarked on the troopship *Intrepid* for the return home to Woolwich. Richard Brough went before the Army pensions board on 13 December, where he was discharged as being unfit for service due to an old injury to his ankles and given a pension of 1s per diem. He was given Marching Money for his return to the place of enlistment – calculated at 1s and 8d per day for sixteen days march at 10 miles per day.

Three years after leaving the Army Richard Brough married Mary Horleston on 7 August 1825 at Stoke-on-Trent and had ten children. As a husband and father Richard returned to his old trade as a brickmaker, living at No. 28 Sutherland Road in 1841 and at No. 109 Stone Road in 1851. They were living in Russell Street, Dresden, in Trentham

parish by 1871 where Richard's age was recorded as eighty-five, and still listed as a brickmaker.

Richard Brough Snr (the soldier) died in 1873 in Dresden, when he was eighty-six years old, and buried at Dresden Church of the Resurrection at Red Bank.

The *Staffordshire Sentinel* reports:

There was said to be living near Trentham in 1831, a young man who was in his twentieth year, and stood at five feet seven and a half inches tall. He was stated to be proportionately robust and displayed wonderful muscular power. Another Trentham giant?

Trentham's tallest man.

The Red Gate pub.

Dresden Church.

John Constable visited Trentham in 1801 when he was living at Fenton. His connection with Fenton came via the Whalley family.

Daniel Whalley was baptised at St Botolph's Aldgate, London 1734, he later earned a living as a cheesemonger, he moved to Great Fenton Hall at Heron Cross.

Daniel and Catherine had six children including Nathaniel, who stayed in London and became wealthy from his cheese business. It was he who became brother-in-law to John Constable when he married his sister Martha Constable. John Constable was invited to stay with his sister's father-in-law, Daniel Whalley at Great Fenton, and arrived at 6.30 in the evening on 23 July 1801. Daniel kept a diary which stated that John Constable rode on horseback with Daniel Junior to Penkhull and back on 28 June.

Before noon the next day – the 29th – Constable walked to Hanford Bridge and back, through open fields and meadows, long before the collieries became established and obliterated the tranquillity. On 22 August Constable visited Spode's factory in Stoke, afore noon. Daniel recorded that on 28 August, Constable went to the Marquis of Stafford's pleasure grounds on foot before noon. He was accompanied by Daniel's four daughters on horseback, which means that another daughter had been added to the brood. Daniel continues, 'on 10 September John Constable and my son Daniel afore noon, rode to Penkhull, Clayton and Trentham, it was a very warm day. The following day on 11 September, Constable rode to Cellarhead and Wetley Rocks.'

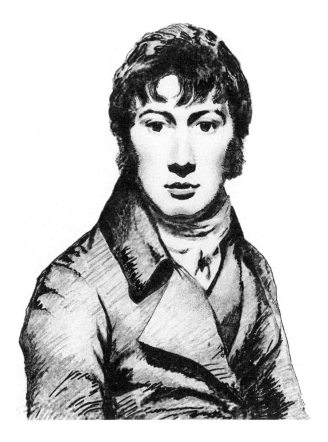

John Constable.

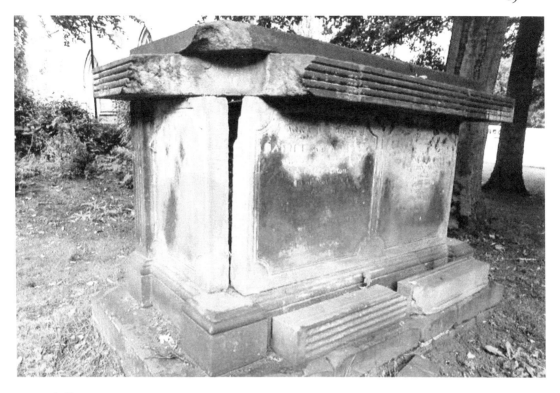

Whalley grave.

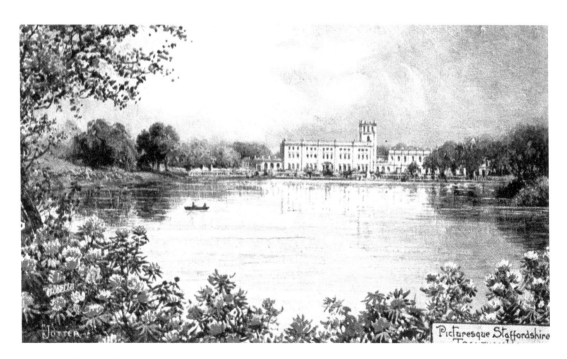

Trentham Hall.

On 16 September he rode to Mow Cop. On 24 September Constable dined and drank tea at Swynnerton,

On 7 October saw John Constable taking an airing at Hanchurch and Acton.

On 23 October saw him taking another airing, this time at Meaford.

John Constable left for London on 17 November, having completed a painting of Trentham Hall in 1803. Daniel Whalley senior departed this life on 29 November 1814 and buried at Stoke on 7 December in a chest tomb. His wife Catherine died at Hanford on 1 March, 1821, aged 83. The Whalley tomb is near to Glebe Road bus stop at St. Peters, Stoke.

The oil on canvas painting of Trentham Hall 1801 is small in size and was purchased by the Potteries Museum and Art Gallery from Sotherby's in 1984.

Walters Bread

James Walters was born in 1862 at Balliol, County Durham. His father was Joel Walters and his mother Elizabeth was born in Staffordshire. The family moved to Knutton where Joel worked in the colliery. Unfortunately he was killed in the pit in 1865. James followed his father in the coal mine and then decided to better himself by becoming an industrial insurance worker. In 1889, he took over a small bakery business attached to a shop in Fountain Street, Fenton. He was living at High Street in 1901 with his wife Ann. James found the business rates high, and with regard for his workforce he decided to build a new bakery. This was the most modern of its kind, built in Marlborough Street, Fenton. The bakery still stands with its date plaque of 1902 on the corner of a street now known as Eveline Street, after his daughter.

Walters Bakery.

Right: Tram tickets.

Below: Hem Heath, Trentham.

James Walters was a president of the North Staffordshire Master Bakers, of which he was a founder member. He regularly attended conferences of the National Association.

Apart from his business his main hobbies were his house and garden, having moved to live at 'Ashleigh' Hem Heath after completion of his new bakery. In his more active days he played bowls and was for many years a member of the Trentham Bowling Club.

James Walters died at his home 'Ashleigh', Trentham, on Sunday 25 April 1948. He was aged eighty-six. He had taken an active part in the bakery business until six months previous to his death, when ill health confined him to his home. An enterprising man who advertised his 'Crown Bakery' on the reverse of bus tickets. Trade adverts stated: 'Hotels, Families & Trade supplied daily. Supplying bread, plain and self-raising flour and confectionary, all manufactured and packed at Crown Bakery, acknowledged to be the best equipped bakery outside London.' James's wife had died three years previously. She had helped her husband throughout his career. His funeral took place on Thursday 29 April at Carmountside

Hutchinson of Blurton

Ann Marbury was born at Alford, Lincolnshire, in July 1591. She was the daughter of Revd Francis Marbury, who was a deacon at Christchurch, Cambridge, and her mother was Bridget Dryden. The reverend was outspoken and was jailed for his subversive views. The family vacated to London in 1605, but on the death of her father Ann moved back to Alford, where she met and married William Hutchinson. They had fourteen children together. Ann retained her interest in religion and grew frustrated at restrictive practices in England. In 1634 a Lincolnshire pastoral leader named John Cotton relocated to the Puritan colonies in New England, America. The Hutchinson's were among the 100 passengers who followed, sailing on board the *Griffin*. She was accused of heresy by the Puritan clergy and exiled in 1638 to New Hampshire, where she helped establish the new settlement of Portsmouth.

Her husband William died in 1642 and Ann moved to Long Island. In the late summer of 1643 she was at the settlement of East Chester, New York, when it was attacked by Native Americans. Ann and five of her children were killed, but her daughter Susanne was captured and spared because of her flame-red hair. She was renamed Autumn Leaf after the colour of her hair. She was with them for four years before being returned to the English. Ann and her daughter Susanne have a bronze statue outside Massachusetts State House.

Two of Ann's children had already left East Chester when the Indians attacked. Daughter Bridget married John Sanford, a pioneer of Boston, America. Her son Edward became a sea captain, but he too was killed by Nipmuc Indians in August 1675. Captain Hutchinson's son Elisha was born in 1641 and became the first Chief Justice of Common Pleas in the colonies.

Elisha had a son, Thomas, born in 1675, who became a wealthy shipowner and merchant. It was he who seized the famous pirate Captain William Kidd in 1699. He had a son,

Thomas, who married Margaret Sanford. His career advanced and he became involved with civil leadership of the colony. In 1771, he was made Governor of Massachusetts.

Like his ancestor Ann Hutchinson, he ruffled many feathers by his outspoken views. He was in charge when the Boston Tea Party broke out in the harbour at Boston in 1773 and was forced to leave for England in 1774. Governor Thomas Hutchinson died at Brampton, London, on 3 July 1780. His eldest son Thomas was a judge and died at Heavitree, Exeter, in 1811. This Judge Thomas had a son William born in 1779, who became curate of Heavitree.

Governor Thomas Hutchinson also had a son, Elisha, born in 1745 and named after his great grandfather Elisha born in 1641. Elisha the younger had a son John Hutchinson born in 1793, who became curate of Trentham and then Blurton Chapel in 1817. Elisha died at Blurton parsonage 1824.

Revd John Hutchinson was the first in a dynasty of Hutchinson's to give religious instruction at Blurton, lasting over 100 years. The building of the new estate at Dresden caused great concern for John Hutchinson, as the rapid growth of its population proved too much for the little chapel at Blurton. The Duke had a new church built at Red Bank in 1853. John died at Blurton in 1865. Next to take on the mantle was his cousin William Pyke Hargood Hutchinson. He was the son of William Hutchinson, vicar of Heavitree, Exeter. He came to Hanford as curate, taking over at Blurton on the death of his cousin John. William served at Blurton until he was a great age, as recorded in the *New York Times* in 17 July 1910: 'London July 9th, the oldest clergyman in England died yesterday. Had he lived another seven weeks he would have been 100 years old. He was appointed to Hanford in 1850 by the second Duke of Sutherland, and to Blurton 1865 by the third Duke. William was buried beside his cousin John Hutchinson.'

His son Sanford Hutchinson took over his father's position at Blurton, being born in 1853 at Hanford. He was a keen historian and did much research on Blurton. Unfortunately he was not as long lived as his father and died on 18 July 1919, aged sixty-five, and was buried beside his father.

His brother Allen was an accomplished sculptor and artist, who decided to travel the south sea's where he met the author Robert Louis Stevenson on Samoa. Stevenson reported home that 'I am being busted by someone named Hutchinson.' The bust was exhibited in London in 1893 before being sent to the vicarage at Blurton, where it was discovered by Allen Hutchinson, many years later, still in its packing case stuffed with straw.

Allen settled in San Diego before returning to London where he died in 1929. Peter Orlando Hutchinson who was the son of Andrew, the brother of William Hutchinson, curate of Heavitree. He was another accomplished artist who lived in Sidmouth, Devon. He came to visit Revd John Hutchinson at Blurton parsonage in 1833 and borrowed the diaries of Governor Thomas Hutchinson. He completed a watercolour of the construction of the new monument being erected at Tittensor to the 1st Duke of Sutherland in 1835, now in Exeter archives. He died in 1897.

Revd William Hutchinson.

His surplice was made into christening gowns by parishioners.

Hutchinson graves.

Blurton's First Headmaster, 1947–67

Born in 1906 into a family of farmers at Cravenhunger, Shropshire, Stanley Mitchell moved to Porthill during the First World War. After passing the pupil teachers exhibition scholarship at Longport Council School, he attended the Orme Boys High School in Newcastle. He then trained at St Paul's Teacher Training College in Cheltenham, where he was head student in his final year.

Mr Mitchell taught at Ellison Street Boys School, Newcastle, Normacot Church of England School and Meir County Secondary School, where he specialised in physical education and music. His work was not confined to the classroom, and he was a pioneer of youth work and became the leader of Meir Youth Club from 1935 to 1947, at the time when the cities education authority was leading the country in setting up a youth service. Under his leadership the club grew into one of the largest and most successful clubs in the city. The service was particularly valuable to the youngsters in the south of the city during the Second World War, when blackout conditions prevailed. An example of his eagerness to offer children new experiences was in 1947 when he organised a trip to take a party of around fifty from the youth club to Sweden.

He was the first head teacher of Blurton County Junior School when it opened in 1947. It had been built to serve the developing Blurton housing estate and grew to be the largest junior school in the city at that time. He was described as a successful and

Left: School certificate.

Below: Blurton School.

well-liked teacher, and the growth of the school with its relevant problems was dealt with professionally. Mr Mitchell prided himself on the fact that by the end of each first school term he knew the name of every new pupil, a gift that helped him build a good relationship with each child.

Mr Mitchell was married to fellow teacher Mary Alcock for twenty-eight years until she died from cancer in 1962. Two years later he received the MBE for services to education.

His second marriage was to Mary Biddulph from Leek, at St Paul's Cathedral in 1973. Mr Mitchell's retirement gave him time to concentrate on the other love of his life – poetry. Aged in his nineties, he wrote a book of poems titled *In Borrowed Time*.

Evening Sentinel, Tuesday 11 March: 'Mitchell MBE died peacefully on 7 March 2003 at the Moorlands Hospital, Leek. Stanley aged 97 years of Westwood Court, North St, Leek. Funeral Friday 14 March service at St. Edward's Church, Leek, at 3 p.m. prior to cremation at Carmountside.'

The Shah of Persia at Trentham, 1873
The Shah of Persia recorded his visit thus:

> We arrived at Trentham Castle, the seat of the Duke of Sutherland. Our train stopped before the gate of the park, where the Duke was waiting, we got into a carriage and drove in. There were lawns, avenues, flowers and deer of the same kind that we had seen at Windsor. The Duke has erected here and there detached houses for his gardeners.
>
> We arrived and alighted at the door of the castle, entered the apartments and went through a private conservatory where we saw varieties of flowers and palm trees. In the centre was a small round basin of water with a fountain, over which was the figure, in marble of a naked woman seated. Beneath this water flowed, extremely clear and pellucid.
>
> We sat there awhile and smoked a Persian pipe, and then went in front of the building where is a large garden, the trees are small shrubs of cypress, larch, and others like orange trees grown in pots, placed out in flower beds and clipped round into globular heads. The flower beds were very extensive and beautiful, the Dukes hothouses which are extremely neat and handsome, being stocked with all sorts of flowers and plants of variegated foliage.
>
> The banana was seen there, which is a pretty looking edible thing like a small long fresh pumpkin.
>
> It has a yellow skin and when ripe has the flavour of a musk-melon, it is soft and in a like manner can be taken with the fingers and eaten, though it is somewhat nauseating. There were also nectarines, peaches, white and black grapes, figs, plums, strawberries, cucumbers and other things.
>
> We returned to the apartments. The edifice possesses grand rooms full of objects, cheerful and adorned with beautiful paintings. The Earl of Shrewsbury, who is a nobleman and has a palace in the neighbourhood with a garden laid out in the Swiss style, was also present. Some English noblemen were present who for years had been the companions of the Duke, a brother, a brother's son and a son of the Duke, were there likewise.

In the evening we partook of an excellent dinner and a beautiful illumination was carried out.

We took a stroll and a place was arranged for the game of bowls. One must throw the bowl with force so it may go and strike certain objects collected together at the other end. Every bowl that strikes an object they take away, I asked the Duke if he played and he and the other Englishmen stripped, took off their hats and played. It was a beautiful game.

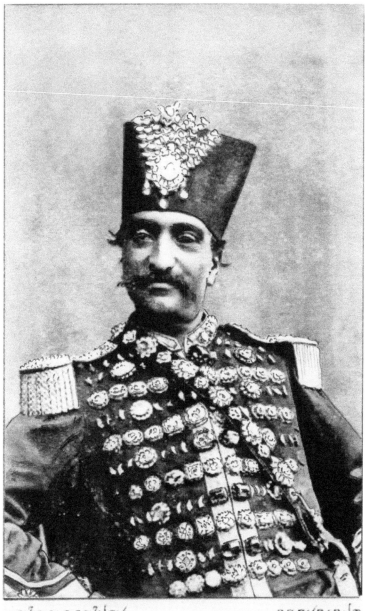

W. & D. DOWNEY COPYRIGHT Shah of Persia.

29

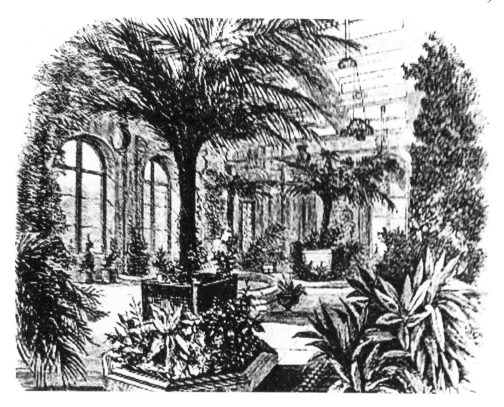

Conservatory at Trentham.

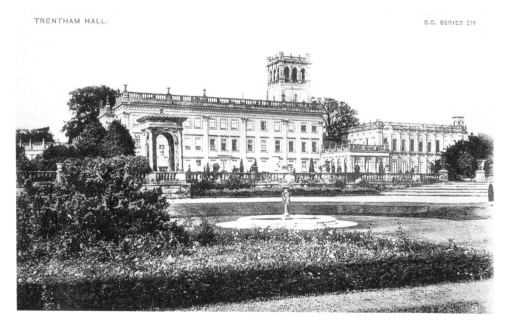

TRENTHAM HALL.

C.C. SERIES 211

Trentham Hall.

2. Leisure

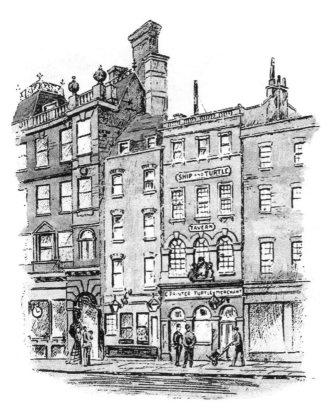

Ship & Turtle.

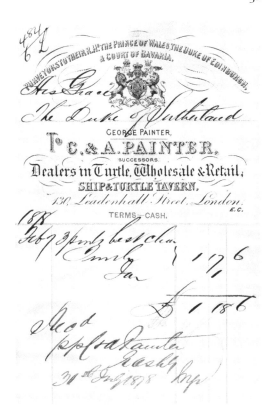

Receipt.

Trentham tart.

A letter from Lady Harriet Cavendish, 28 August 1810, from Trentham Hall says:

> We arrived here yesterday in time to drive over the park and beautiful wood.
>
> The house is comfortable with two fine rooms. We fared sumptuously at the rich man's table.
>
> The dinner for us two was soup, fish, fricassee of chicken cutlets, venison, veal, hare, vegetables of all kinds, tart, melon, pineapple, grapes, peaches, nectarines, with wine in proportion. Six servants to wait on us, whom we did not dare dispense with, a gentleman in waiting and a fat old housekeeper hovering around the door to listen if we should chance to express a wish. Before this sumptuous repast was well digested- about four hours later, the doors opened and in was pushed supper of the same proportion, in itself enough to have fed me for a week. I did not know whether to laugh or cry.
>
> The house is full of portraits, some amuse me more than the rest. Two of Lord Stafford, positive and important, three of Lady Carlisle, very handsome, but less so than I have always heard she was, and last but not least, Granville, between three and four, dancing with his sisters. Also, one of the late Lady Stafford and several of her husband, who must have been a magnificent old man.

Trentham tart was another delicacy to escape from the hall kitchens. Take 4 ounces of shortcrust pastry, 2 ounces of butter, 2 ounces of castor sugar, 4 ounces of self-raising flour, onw egg, a quarter of a teaspoon of vanilla essence, half a tablespoon of cold milk, raspberry jam, and icing sugar. Line the pastry case with pastry, spreading jam thinly on the bottom. Mix the butter, sugar and vanilla until light and fluffy. Beat in the egg with a tablespoon of sifted flour. Fold in the rest of the flour with the milk and place on top of the jam. Bake in centre of the oven at 375 degrees for thirty minutes. Ice the top when cool, leaving one inch from the edge. Decorate with seven glace cherries and seven walnuts, a split walnut sits aside of a single cherry in the middle of the cake. Eat like a duke!

Millicent, Marchioness of Stafford
Tuesday 2 July 1889:

> *How I Spent My Twentieth Year* has been reviewed for the *Aberdeen Free Press* by a writer who had the good fortune to be a fellow traveller with the Marchioness of Stafford in part of her journey round the world. The young lady fresh from school may now travel round the world in comparative comfort, and if she is bright, amicable and earnest, and records her impressions without affection, she need not fear the lack of patient readers.
>
> The youthful Marchioness of Stafford makes her concise accounts on men and things with a charming quaintness, which reminds one of the immortal Pepys – minus the conceit of self-admiring diaries. The information gleaned may not always be absolutely accurate, though the general reflections may be, for all practical purposes, sufficiently correct and instructive, nor is the author less at home in describing life on board our great mail steamers.
>
> 'The dear old Shannon', which she fondly and frequently refers to, supplied the usual 'characters'. The inevitable 'John Bull' and his wife – always ill and always eating – to

say nothing of the 'funnyman' who is supposed to conduct the choir. All are caricatured very kindly and very faithfully – yes, some say faithfully – for the present writer may as well confess at once, that he had the privilege of being a fellow passenger on this particular voyage, the tedium of which is not too much to say, all on board felt very much relieved by the genial, bright and cheerful person of the Marchioness, while her tender sympathy for afflicted ones of all classes showed a warmth and fullness of heart not often conspicuous among the youthful nobility.

She took a special interest in the evangelical services of two Baptist ministers – one of whom, she says 'Is, I fear, dying of consumption, but so bright and patient.' It may interest the young Marchioness, whom this poor fellow often blessed, to know that her fears were only too well observed. He died within three months of reaching Tasmania. Another victim of heartless cruelty of home doctors in sending abroad hopeless patients.

Bravely does the Marchioness stick to her log, which indeed goes on improving day by day, until England is reached after an absence of nine months. We hope this may not be the last book of travels from the same pen, and when she next sails, may we be there to see.

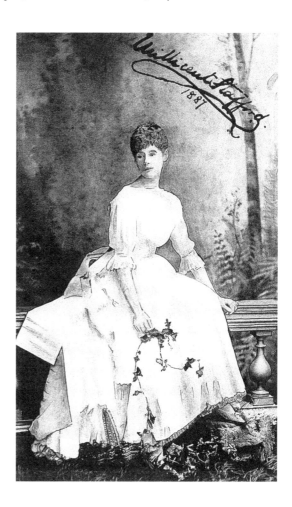

Millicent, Marchioness of Stafford.

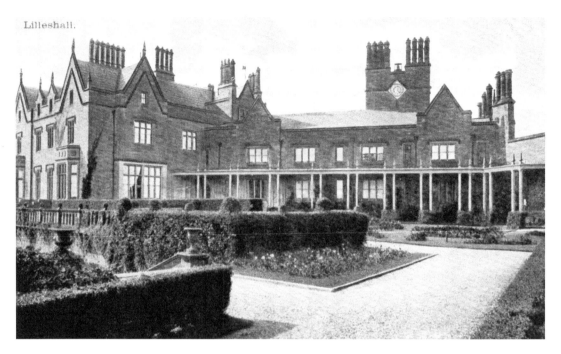

Lilleshall Hall.

Lilleshall Gardens.

Cats and Dogs

A Scottish wild cat had been caught in a trap on the duke's estate in Sutherland, Scotland, by the foreleg, which was much injured, but not so as to prevent it moving with great alacrity, even with agility, endeavouring frequently to use its claws of both forefeet with a desperate determination and amazing vigour. It was a very powerful animal, possessing great strength, taking size into consideration, and of extraordinary fierceness. Mr Fred Wilson, the show manager, though an excellent naturalist, tried to get it out of the thick-barred, heavy-made travelling box in which it arrived, into one of the ordinary wire show cages, thinking it would appear to a better advantage. However, in this endeavour he was unsuccessful, the animal resisting all attempts to expel it from one to the other, making such frantic and determined opposition that the idea was abandoned. The wild cat maintained its position, sullenly retiring to one corner of the box where it scowled, growled and fought in a most fearful and courageous manner during the time of its exhibition, never once relaxing its savage watchfulness or attempts to injure even those who fed it. The reporter said he never saw anything more unremittingly ferocious, nor apparently more untameable. Another report said 'the Scottish wild cat caught recently on the Duke of Sutherlands estate, a savage varmint it is still, and frets against its bars, or moves uneasily about, holding up its wounded paw, a joint which had been snapped off in the trap'.

At the dog show at Inverness in 1874, the animal that attracted most attention in the show yard, and which the judges pronounced the finest dog exhibited, was a magnificent specimen of the Russian Siberian wolfhound, graciously sent by the Duchess of Sutherland, who had received it as a present from the Emperor of Russia and brought back to this country by the Prince of Wales. The dog was a pure white animal of a very large size, 32 inches in height at the shoulder, and attracted crowds all day. It was the first dog show ever held north of Aberdeen.

At Lilleshall Hall, the Shropshire home of the Dukes of Sutherland, lies a large square block gravestone engraved 'Czar'; a Russian wolfhound lies here. He was presented in 1856 to the Marchioness of Stafford by Alexander II, Emperor of Russia, given at the Czar's coronation.

Buffalo Bill's Trentham Connection

In late April 1985 a reporter was sent from the *Sentinel* to sniff out a rumour regarding the story of Buffalo Bill at Loggerheads, better known as a fresh air sanatorium amid the pines for the recovery of pottery folk with serious chest complaints, including tuberculosis.

He was drawn to the Ivy House Farm, which had previously been a pub called the Ring O' Bells. Some forty years ago, prior to 1957, it being moved to another part of the farm, stood a railway waggon, the remains of which bore the legend 'WILD WEST SHOW' and the name William Cody.

It had in all probability been used to transport horses, since some of the hooks and chains by which the animals were tethered were still there. The floor and chassis were long disappeared, as had most of the paintwork, but the timber framework was in a remarkable condition after being exposed to the elements for nigh on half a century.

Mrs Eva Noden was born at the Ivy House and is still living there. She said the old waggon was a caboose and was their poultry house. It was brought from Stoke around 1910.

Local legend says that Buffalo Bill wintered his horses at Lea's Farm. John Harrison's daughter Elsie, of Studley Farm, Muckleston, kept a scrapbook in which is pasted an article written by a Malcom F. Grey for the *Market Drayton and Newport Advertiser* entitled 'Yes sir, Buffalo Bill came thisaway', based on an interview given by his father thirty years ago.

John Harrison (1880–1961) worked on Studley Farm from 1905 until he retired fifty-three years later. However, before that he worked for the Lea brothers, John and Washington, who farmed at Audley's Cross, and at Blore for a short time too. He had been a gamekeeper for Sir George Chetwode of Oakley Hall. Here, there was a witness of an event, and a date of 1904.

A search of the *Sentinel* archives revealed that Buffalo Bill and his Wild West Show were at the Old Racecourse, Boothen Farm, Stoke, on Monday 25 April 1904. In the early years of the century farmers were almost ruined by cheap imported goods and were glad to let out their land to Bill Cody during the winter months. John Harrison recalled that Buffalo Bill and his cowboys took over both farms, and although they were a lively lot – they loved shooting and coursing – John Harrison was an expert because of his gamekeeping experience at Oakley Hall. The cowboy's main task was the care of their livestock. To this end they built a veterinary surgery at Blore. It still stood, as did a similar building at Audleys Cross Farm. Both had semicircular corrugated-iron roofs and wooded walls, each strengthened by 1-inch diameter iron rods, similar to those on the waggon at Ivy House Farm. That the buildings still stood was a tribute to the cowboy's skills and the materials used.

What is this to do with Trentham? Enter Theophilus Ernest Cornforth, born in Kingswinford in 1831. Moving to Basford, he took to building railway stock and dealing in second-hand locomotives and rolling stock at Cockshutt Sidings. Theo was living at 'The White House', Victoria Road, Trentham, by 1900.

Cockshutt Railway Sidings were next to the Globe Works and they were used as winter quarters for Barnum and Bailey's Circus from 1897 to 1911. Buffalo Bill toured with his Wild West Show using Barnum and Bailey's rolling stock in 1903 and 1904, and at the end of the tour the stock was returned to Etruria, where they were acquired by Ernest Cornforth. They had originally been built by him and nicknamed 'Barnums' due to their specific use in the circus, Cornforth sold many old carriages privately to farms and one stood behind Blurton Tollhouse for years, used as housing.

Right: Buffalo Bill.

Below: Members of the show.

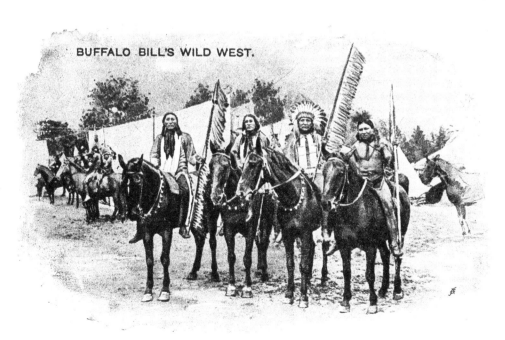

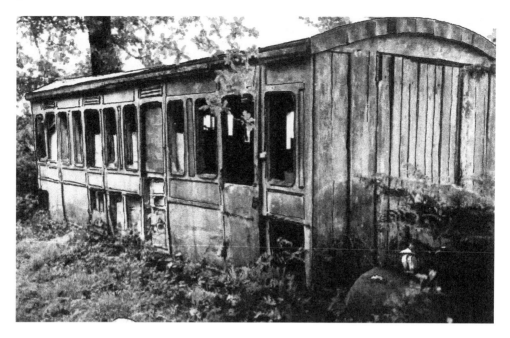

One of the old carriage.

The Wakes at Trentham Park, 12 August 1854

Our visit was made on Trentham Thursday. On passing through the gates we found the scene was cheerful, we never saw a better-looking, or a better-dressed, or better-behaved company.

Some 60,000 individuals were present during the afternoon, of this number 4,000 took tickets from Stoke, and 1,500 from Longton, the number of conveyances was great in number, and the crowd of pedestrians multitudinously greater. We walked from the borders of the gardens near the pool to the heights overlooking the park and ducal residence. The spires and towers of numerous churches received attention. Manufactories with their many smoking chimneys-mansions, partially deserted by their occupants, and towns, all but tenantless, were clearly or hazily visible.

The ducal owner of that park and magnificent hall, with his large and warm heart encouraging his rich and poor neighbours to make themselves at home on his green lands, these merry groups, happy couples or solitary ramblers roamed over his domain.

We moved to the open space beneath the shadows of the noble trees. At one point, we felt that some tribe of harp, violin, accordions, guitar, hurdy-gurdy and organ players had entered into a conspiracy to besiege the visitors with their sweet music. There was everywhere Scotcher and his band, with the largest company of dancers in the park. The drum and fife bands everywhere.

Our eyes glanced at the parties of family groups – fathers, mothers and children – with friends from a distance enjoying themselves and making the park a meeting place.

But eventually the evening came gently down and we re-walked to the station.

Trentham Thursday

The partial opening of Trentham Gardens first occurred in Wakes Week 1835, and Trentham Thursday started in around 1840. This was the first Thursday of August in the Wakes Week.

This date was eventually settled on as an annual event by the Sutherland Family, as it coincided with them being away in Scotland.

The Thursday holiday in the Potteries is much older than 'Saint Lubber's Day' as August bank holiday was formerly called. It originating from 1840, when a local business lady gave her staff the day off, with her initiative securing from the Duke of Sutherland, the privilege of admission to the grounds for members of her staff, that other firms gained the same concession, until the Thursday in Wakes Week eventually developed into a general holiday in the Potteries.

Tourists from the pottery towns made Ashley, near Loggerheads, a popular weekend resort from the 1870s. They were encouraged to forgo Trentham in favour of Ashley.

The *Sentinel* of 9 August 1929 reports: 'Changed conditions are making their influence felt in altered aspects of many characteristic Potteries institutions. Of this kind, no event in the North Staffordshire year could be more typical of local ways than "Trentham Thursday" – the annual invasion of Stokes most popular beauty spot by armies of workers released from labour by the general closing of business's all day on the Thursday of Wakes Week – and to the observer at Trentham yesterday, changes were apparent even in this firmly established holiday.'

Thursday's merry making at the former seat of the Duke of Sutherland was enjoyed by thousands of people with the whole-hearted jollity for which the North Staffordshire people are famous. Despite dull skies in the morning, buses plying to the gardens, as well as trains, were well patronised, though there were scarcely such lengthy queues as have been seen in recent years.

Stars All Around Us

DID YOU KNOW?

The American jazz singer Elisabeth Welch lodged in Dresden. Elisabeth Margaret Welsh was born in New York City on 27 February 1904 to John Wesley Welsh and his wife Elisabeth Kay. Her father descended from black slave workers, whose owner was named Welsh and her mother was Scottish. The singer described herself as black Native American and Scottish Irish.

Elisabeth's father always called her 'Girlie' to stop confusion with her mother Elisabeth. Elisabeth never liked the name Welsh and in 1928 she changed it to Welch. Elisabeth came to London in 1933 and never returned home; she said she had an English heart. She disapproved of being called a jazz singer and preferred to be known as a singer of popular songs. Her signature tune became 'Stormy Weather'.

In 1934 her agent persuaded her to tour the country in variety shows. It was during this time that she stayed at No. 127 Belgrave Road, Dresden, with Ernest and Olive Carr. Olive said she was a lovely lady and would never have a bad word said against a black person from that time on. Elisabeth was appearing at the Empire Theatre in Longton and needed lodgings. She was a pioneer in television, appearing from North London in 1936, and she was one of the first black women to appear. She was on a radio series called 'Soft lights and Sweet Music' in 1934–35 and was on the radio more or less every week.

She died in London on 15 July 2003. Her stay with the Carr family at Dresden was now family legend.

Another famous person from Dresden is the actor Freddie Jones. He was born on 12 September 1927 at No. 7 Villiers Street, Dresden. His parents were Frederick Charles Jones and Ida Elizabeth née Goodwin. Fred had always been interested in acting and took part in the scout's show *Screamline*; he took up acting as a sideline. In 1958 he was given his first professional engagement on a ten-week tour in *Romeo and Juliet*. When the tour ended several auditions were waiting for him. His film debut came in 1967 when he played Cucurucu in *Marat-Sade*, filmed at Pinewood. Two years later he made his mark by playing Claudius in the six-part mini-series *The Caesars* where he confessed that his limp was perfected by placing a pebble in his footwear.

His mother was killed by a car crossing the road from Dresden Church and is buried at Dresden with her husband. Freddie is an international star now.

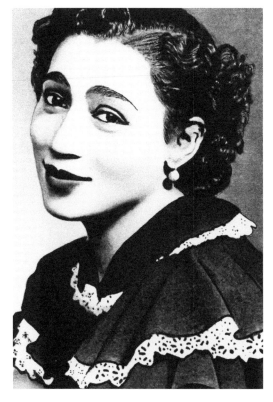

Elisabeth Welch.

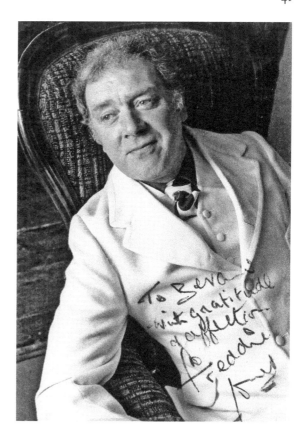

Right: Freddie Jones.

Below: Empire Theatre.

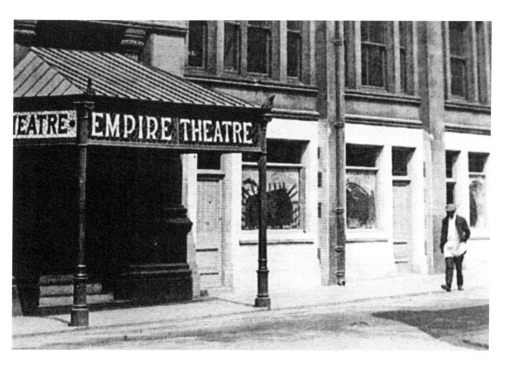

The Late Sir Arthur Pearson's Pet Charity (Advertisement)

Pearson's
FRESH AIR FUND
DURING the Forty-Six years of its existence the FRESH AIR FUND has given 6,395,686 poor children a day in the country, and since 1908, when the fortnightly holidays were inaugurated, 119,252 children have enjoyed two weeks by the sea or in some rural retreat. The only passport to a Fresh Air Fund holiday is the need of the child.

24th JULY 1906
On Friday last week, thanks to the generosity of Pearson's Fresh Air Fund, 500 of the poorest children of Longton gathered at The Queens Park to partake of the good things provided for them, in connection with what has become an annual event. On arriving at the park each child was given a bag containing sweetmeats, and when all the children had arrived, games and sports were the order of the day. Balls and skipping ropes were provided for the children, and a willing band of helpers, amongst who many were head teachers, organised a series of races etc. The prizes offered being eagerly competed for. A Nigger Minstrel entertainment was also provided for the enjoyment of the children, and

'Fresh Air Fund' advert.

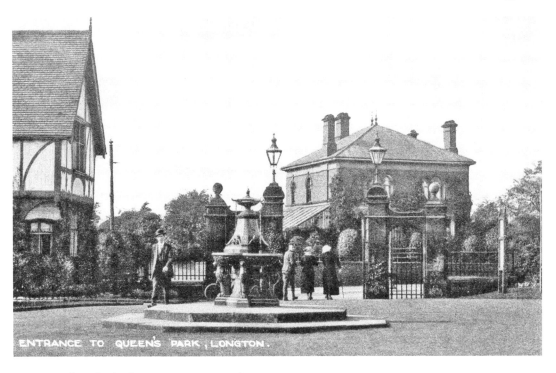

Queen's Park, also known as Longton Park.

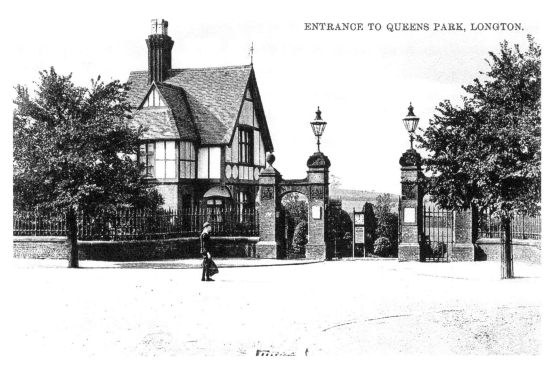

ENTRANCE TO QUEENS PARK, LONGTON.

Queen's Park.

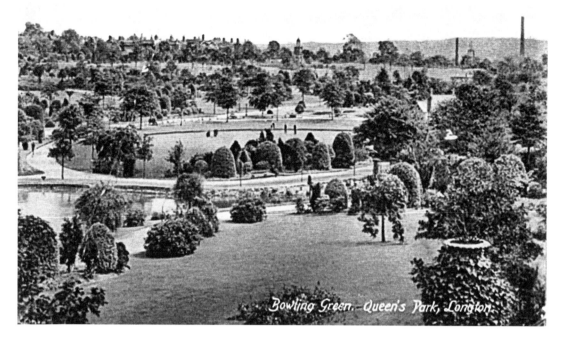

Queen's Park.

Trentham Road junction, 1964.

The same junction in 1994.

this was greatly to the taste of the youngsters. At four o'clock the children sat down in ranks, and under the superintendency of the Mayor, tea and provisions were provided. Each child received a bag containing a meat pie, a lunch cake, and a buttered scone, whilst an excellent brew of tea washed it down. After tea games were again indulged in, another entertainment was given by the Minstrel Troupe, and afterwards nuts were scrambled for and chocolate was distributed among the children, time passed quickly, as all happy times do, until the children were marshalled for departure. Each child as it passed through the gates, received a bag containing a bath bun and a banana, the children had a riotously happy time and thoroughly enjoyed themselves.

Newcastle-under-Lyme Bachelors Club

The Newcastle-under-Lyme Bachelors Club Ball took place at Trentham Ballroom on Thursday 23 February 1939. Its popularity had long been established, and it annually raised a substantial profit for the North Staffordshire Royal Infirmary. The ball was organised by the Newcastle Bachelors Club and there were parties of dancers from outside Newcastle to join the many ladies and gentlemen from the locality. Those who had the ball on their list of engagements welcomed the news that Al Berlin and his orchestra had been engaged to provide the music. Aged twenty-three, Al Berlin, who was nephew to the famous dance tune composer Irving Berlin, was rapidly becoming one of the leading lights of the dance music world. He had his first band when he was still at school, and later went into revue. Al and his band obtained a great continental reputation, and successfully toured Switzerland, the south of France and north Italy, following a month's engagement at Cafe Zinlporte, Zurich. The band was particularly popular at Trentham, for they were engaged there for twelve months after their continental tour. Then they toured dance halls and theatres in Birmingham, Brighton and London. Al Berlin and his orchestra broadcast frequently from this country and the continent.

There were twelve members of the band and Al's vocalists Eddie Lester and Sidney Lewis sung in English, Italian, German and French.

Many novelties were planned, including a Lambeth Walk competition for Bachelors over seventy, but the club took care that such events did not interfere with the dancing. Late buses were provided and proper car parking plans made. Dancing was from 8 p.m. until 2 a.m.

Trentham Ballroom

When it opened it was called Trentham Entertainment Hall, completed in 1931 and advertised for use on 27 June of that year. The information stated that it was available for functions, dancing, etc. Large parties catered for with 18,000 square feet of polished maple wood floor. The finest ballroom in the provinces, Trentham Gardens Ltd was established in 1931 when it had the Carnival Queens, where young ladies were selected by each district to be their queen. The new entertainments hall charged 6d admission, with an extra 3d for admission to the Carnival of Queens show. Gates opened at 1 p.m. In the evening, the entertainment hall came into its own, with dancing to the new panatrope, belonging to the Trentham Gardens Co. The panatrope was the first fully electric phonograph, in other words, a large gramophone.

The panatrope played 78 rpm records such as 'Fall in and Follow the Band' by Gracie Fields. On the B side was a song recorded by Gracie called 'Sally', which became her signature tune. Gracie became famous after her manager advised her to watch an already famous singer from the theatre wings and to 'sing like her'. The singer she imitated was named Gertrude Astbury, who sang and yodelled, as did Gracie later in her career.

Gertrude Astbury came from Hanley and joined a travelling troupe, who nicknamed her Gertie Gitana, because of her gypsy-like looks. Her big hit was 'Nellie Dean'.

The entertainment hall is no more, having been demolished in 2002 for a garden centre/restaurant.

Dancing at Trentham.

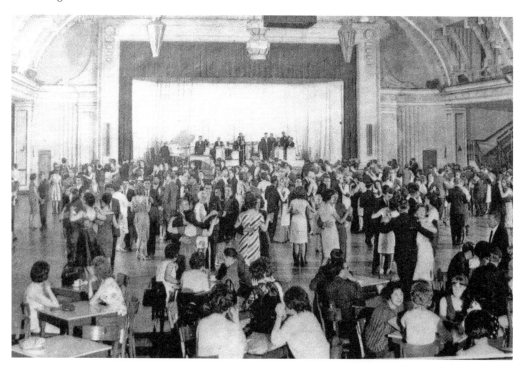

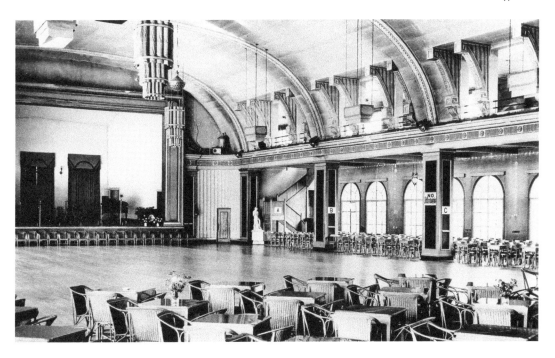

Trentham Ballroom.

Ballroom from the gardens.

3. Community

Trentham Poorhouse

The first Trentham poorhouse was built over a mile away from Trentham village at Blurton. A new poorhouse was built in 1809 off Trentham Road on land given by the Duke of Sutherland, right on the edge of Trentham parish and close to Longton where the inmates could be put to work instead of being idle. The institution had capacity for fifty-six inmates. In 1839 it housed three able-bodied men, five youths, ten boys, nine able-bodied women, four temporarily disabled women, seven older girls and one infant. The third floor was used for sleeping. The poorhouse rented land on which the inmates grew vegetables to help support the institution. Cows, pigs and poultry were kept in the outbuildings. Part of the house was private accommodation for the master and matron. The rules at Trentham Poorhouse were strict and recorded in a book, which is at Hanley Records.

Poorhouse entrance.

Trentham Poorhouse.

The Trentham Poorhouse was short-lived and closed in 1841 when a new poor law was introduced, making Trentham part of Stone Union Poor Law. All the poor now had to go to Stone Poorhouse beside the canal, which later became the Trent Hospital.

The old Trentham Poorhouse was made into two private dwellings and occupied by professional people. The building still stands hidden off Trentham Road.

Congregational Church, Dresden

Congregationalism was established at Hanley and a church built there in 1780. A Congregational church was established when an evangelist was sent to preach at Belgrave Road, Dresden, in 1867. A newspaper report of 16 January 1885 says:

The new congregational church which has for some time past been in course of erection on the site recently occupied by the old iron structure in Belgrave Road, Dresden, was on Wednesday afternoon opened for divine service.

The building is a plain substantial looking edifice of classical character. It has a frontage to Belgrave Road of 61 feet and extends back a distance of 42 feet. The material used in its construction are the local yellowish- brown bricks and red pressed bricks with moulded strings, quoins and arches in bright red bricks. The stonework is executed in hard red Roche.

Purple Broseley tiles cover the roofs, with the exception of the dome of the tower, which is sheeted in metal. The entrances are picturesquely grouped at the sides, one

of them terminating with a balustraded parapet, and the other with a domed tower. The glazing is entirely of plain sanded glass of a faint antique tinge in lead quarries.

The interior of the building is quite in keeping with the exterior. It contains a plain arched roof, the stalls and other woodwork are executed in pitch pine, and the aspect is altogether a pleasing one.

As it at present stands, the church will seat about 400 worshippers.

Messrs. William Sugden & Son of Leek were the architects, and the contractors for this work were Messrs. Inskip Brothers of Longton.

DID YOU KNOW?

The architect of Dresden Congregational Church came to the area for work and never returned home. William Sugden was born at Keighley, Yorkshire, and came to Leek in 1849 to work on building designs for the Churnet Valley Railway stations and decided to stay.

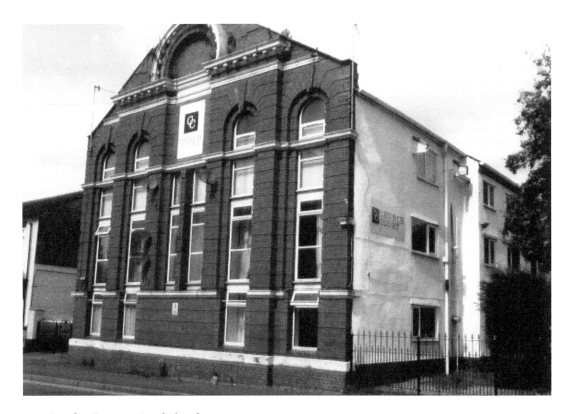

Dresden Congregational Church.

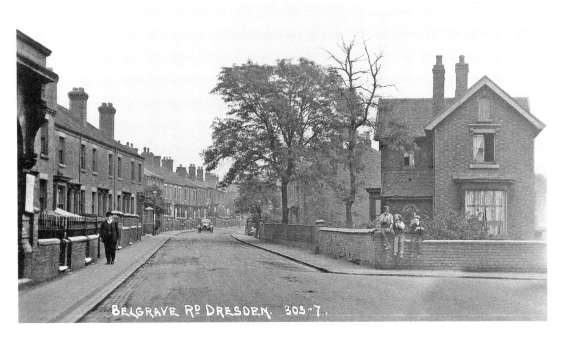

Belgrave Road.

The Tower House

The house was built for Mary Ann Prockter, who was baptised on 29 January 1814 at Bethesda Chapel, Hanley. She was the fifth child of John and Hannah Robinson. She was born on 10 September 1810 at Longton. John Robinson married for a second time to Hannah Lockett on 14 November 1802 at the New Connection Chapel. She was the daughter of George Lockett, who was in partnership with John Robinson as pottery manufacturers until 1818. Mary Ann's father, John, was born in 1766, and after his partnership with George Lockett he entered into a new one with Jonathon Lowe Chetham in 1822. He was living at Greendock, Longton, in 1829. The site of his pot-bank was next to The Union Hotel in High Street. By 1837 John was in partnership as Robinson, Wood and Brownfield. He died on 12 September 1840. His will was proved at Lichfield on 24 May 1841. George Lockett married Ann Wilson Sutton, who must have been a relation of the architect of Tower House. George Lockett went into partnership with William Cooper at Wellington Pottery Works, Stafford Street. He later went into partnership with George Arthur Robinson. They were both Methodist preachers at Bethesda Chapel in Hanley.

George Lockett was an attorney by 1841, aged thirty-four, and living at Bridge Street, Longton, with wife Ann Wilson, aged thirty-five, who was born in Nottingham. They had a son named John.

When John was aged sixteen (in 1861) he was a solicitor's clerk, probably working for his father. By 1871 he followed in the family tradition as a pottery manufacturer and was living at No. 17 Red Bank, Dresden, along the road from his aunt Mary Ann Prockter. Ten years later he had moved to No. 65 Carlisle Street.

A report in the *Staffordshire Advertiser* says that on 16 February 1829, Thomas Burrow, a grocer from Hanley, married Mary Batkin, and at the same time and place Elijah Burrow married Mary Ann Robinson. A search of the church records reveals that no such wedding took place: Elijah was a witness at his brother's wedding and Mary Ann was only nineteen years old at the time. Her wedding was found at St Peter's, Stoke, on 13 December 1835 to a John Deakin, and she is described as a spinster. They went to live in Orchard Place, Edensor (Willow Cottage). John Deakin was born in 1811, son of James Deakin of Hillside. They had a pot-bank at Waterloo Works, built in 1815, the same time as the Battle of Waterloo, which had a date stone on one of the four bottle ovens. John Deakin died in 1846 leaving Mary Ann a widow; she was aged forty and living at Daisy Bank, Edensor, Longton, with her sister Hannah, aged twenty-eight, and her widowed brother Samuel. Mary Ann and her sister were the proprietary of houses – in other words landlords of property, which they rented out.

Mary Ann Deakin née Robinson married for the second time to James Simpson Prockter on 15 September 1853, again at St Peter's, Stoke. His father was Samuel Prockter from Bermondsey. The marriage was short-lived as James died four years later at Morden Hill, Lewisham. He was buried 31 January 1857 at Norwood Cemetery, Lambeth, aged fifty-six.

Mary Ann purchased a building plot from the Longton Freehold Land Society, which was planning a new estate at Spratslade to be called Dresden. It was alongside Bridle Path, completed in 1865 and named Moneta House, No. 53 Ricardo Street. She was a woman

Tower House.

Bridle Path.

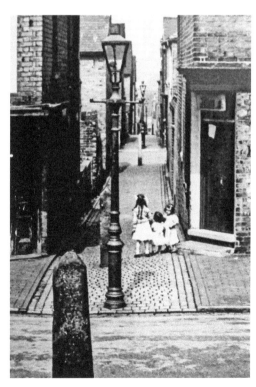

Bridle Path, 1956.

of means and splashed out on its design. She named it Moneta after Moneta in Bedford County, Virginia. The 1871 census reveals she is a fifty-nine-year-old widow sharecropper with money on mortgage. It appears that she owned or had shares in a tobacco plantation in Virginia. In 1865 the slaves on the plantation were freed but refused to work for wages, as this enabled their former masters to still give the orders. A compromise was reached with share cropping where the plantation owners supplied seed and equipment in return for half of the profits from the harvest. A bad harvest meant that the workers could end up in debt. Mary Ann died at Moneta House on Saturday 27 January 1873 and it was put up for sale along with its contents. Her will was proved at the principal register office on 11 April 1874.

A Visit to Hanchurch Convalescent Homes, 4 August 1906

It is curious how vague many people's ideas are of local topography when they are put to the test. It would be interesting to know how many people there are in the Potteries who could not say offhand where the home is and what distance it is from any given point. The twenty-minute walk across the fields from the tramway terminus at Trent Vale lengthened out into a warm 2-mile-pull uphill, but when the top of the ridge at Hanchurch was reached, the beauty of the surrounding scenery amply rewards the effort, even though the black pall of smoke that indicated the whereabouts of the Potteries in the distance was somewhat of a blot on the landscape. However, the glorious setting sun, the picturesque range of hill and dale, the luxurious woods, the sweet scents of the country, and the activity of the birds were all delightful, and one realised once more how true it is that there is scenery so enchanting within easy reach of the Potteries . Hanchurch itself is a mere hamlet. The home lies on the other side of the ridge and, looking away from the Potteries, is innocent of the blur far away in the rear.

The first meeting in connection with the Hanchurch Home was held at Trentham Hall on 4 January 1893, when the Duchess of Sutherland announced that the duke would build and furnish a convalescent home for poor children of the Potteries.

The home, built on the bungalow principle, is approached by a smart drive and stands amid lawns and trees. A passer-by might think that it was a gentleman's spacious summer residence. It looks westwards towards the Hanchurch Woods and Whitmore, and southwards to the timber of Trentham Park. The view is upon a grand scale, the air is delicious, the peace and calm and brightness could not be more welcomed by denizens of the towns.

On Tuesday evening, just as the writer arrived, the little girls were returning from a picnic in Hanchurch Woods, where they had been since dinner time, having had tea beneath the trees. These picnics are frequent and always enjoyed. As the children came clattering down the road, it was easy to see that happiness reigned supreme, and that their stay at Hanchurch was a great event in their young lives.

It will be promptly discovered by anybody who looks into the affairs of the home that the duke and duchess have built and equipped, and do much for its maintenance and for the enjoyment of the little inmates. The children are fitted out with pretty clothes to wear during their stay. The girls wear navy serge dresses, white pinafores, black stockings, red cloaks and Tam O' Shanters, pink cotton washing dresses for playing in the summer,

white dresses for best, and on Sundays straw hats with bands of the Sutherland tartan. The boys wear navy blue man o' war suits, scarlet stockings, red fronts and red Jersey caps, serge knickers and washing blouses in summer.

The children are bathed three times a week and greatly enjoy it. They spend the time in romps and games, walks and picnics. There is a shed for wet days. There are some capital swings in the garden. There are simple prayers morning and evening. Those who can do so walk to Trentham Church on Sunday mornings. All attend a service at the chapel of ease on Sunday afternoons. Breakfast is at eight – porridge, bread and butter, marmalade, sometimes bacon and plenty of milk. Dinner is at half past twelve – meat, vegetables and pudding. For tea at 1.30 the children have bread and butter, cake and jam, and at supper at 7.30 they have pudding, bread and butter with jam and always plenty of milk.

Sister Baldwin, the matron, manages the house with the help of two maids and is well beloved by her little charges in return. When they get home again they write to her, some tramping long distances to see her, sometimes investing a copper in a flower for her because they know she is fond of flowers. Sister Baldwin is a native of Norfolk. She was on the late Miss Shirley's nursing staff, then she went to Trentham as a nurse and had returned to hospital work when she was recalled to become matron of the Hanchurch Home. It was a fortunate appointment. The home could not have a more kind, skilful and reliable manager, or the little ones a more conscientious and loving superintendent. Mr Spanton, as the chairman, is tireless in his interest in the home and Mr Coghill is another warm friend. Some of the children of course are not well equipped with clothes when they arrive. Where necessary and as far as possible, they are given better clothes to wear when they leave. The old clothes of the home are given away.

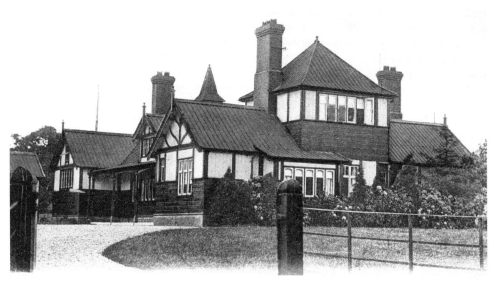

HANCHURCH HOLIDAY HOME, NR TRENTHAM

Hanchurch Homes.

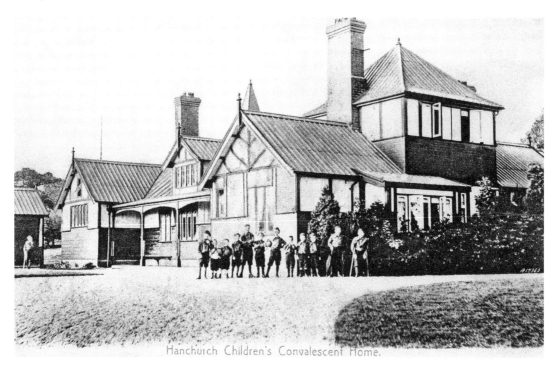

Children at Hanchurch.

Christian radio station.

Trentham District Nurse French

Edith Emily French was born on 24 September 1873 at Yarm, on the south bank of the River Tees in the North Riding of Yorkshire. She was admitted to Bishop Hill & Clementhorpe School for Girls, York, in 1880, aged seven years old. She was there for five years until she was taken to St Mary Bishop Hill Senior School, York, in 1885, aged twelve. After she had finished her schooling she enrolled at the City of London Lying-in Hospital to train as a midwife.

Edith's father was named Henry French and he was born in 1831 at Northfield End, Henley-on-Thames. Henry obtained work as a footman at Westminster. He married Jane Morley, whose father was a lieutenant in the Royal Navy. Edith's father advanced to the position of butler at Gunnergate Hall, Marton-in-Cleveland, York. She came to work as a district nurse for the Trentham Nursing Association, living at No. 3 Ash Green by 1919. Nurse French purchased the house she was living in at Trentham when the estate was sold.

She retired to Stamer House Nursing Home, Oxford Street, Penkhull, where she died on 7 May 1954 in her eightieth year. The *Sentinel* states she was for many years 'the District Nurse of Trentham. Beloved daughter of the late Henry and Jane French. Service at Trentham at eleven o'clock May 12th, followed by cremation at Carmountside. Her probate was proved at London 20th July. Edith Emily French of Ash Green, spinster. Effects to Norman French, Chief Bank Cashier, £1,732. 5s. 1d.'

Nurse French's house.

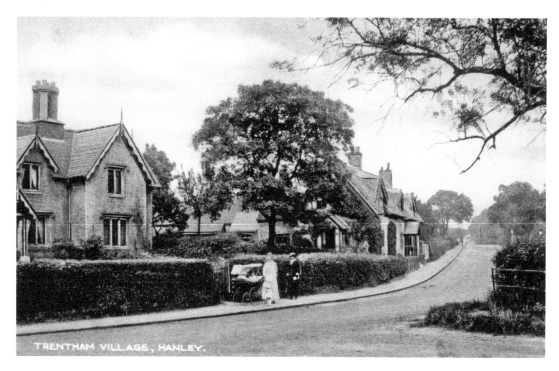

Ash Green.

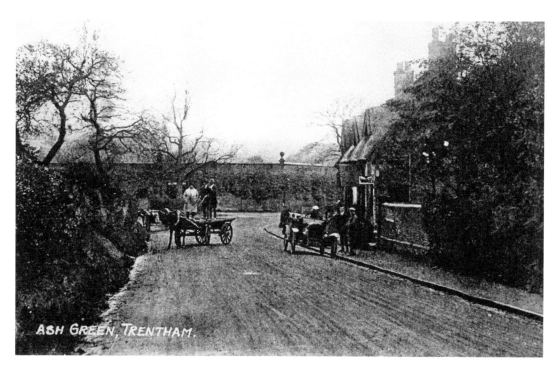

Ash Green.

Trentham Nursing Association: 'Mr. Prowse will recollect that until lately, the estate almost entirely financed this Association over which at the same time however, the Trustees had no measure of control.'

Trentham Estate memorandum, 15 December 1916: 'Nurse French. The Trustees provide this house rent free. Should the Nursing Association pay the water rate thereon which amounts to £1 a year' (answer: yes).

Trentham Estate memorandum, 19 December 1916:

It was decided two years since that the time had now come when the parishioners of Trentham should realise that their responsibilities in this matter were not confined to its management.

It was therefore decided that in future in lieu of the Trustees continuing to give a yearly subscription of £45 and finding a free house worth £15 a year, that the cash subscription should cease; but that the allowance of a free house be continued.

Such would have course, be the equivalent of a yearly subscription of £15.

Though no responsibility for interior upkeep was undertaken, the Nursing Association Committee now prefer a further appeal to the trustee's generosity and ask if this house may be re-papered and re-painted, which must mean an expenditure of £12 to £13. The reason advanced for the making of this appeal is shortage of funds.

I put forward for Mr. Prowse's consideration a list of Association members and their subscriptions.

I think he will say that if the majority of the people only care to open their hearts, there would be no need to now make this begging appeal.

I think I ought to say that if it is decided to comply with the committee's request the work would be done by our own workmen, at such time as we can conveniently undertake it.

Therefore, I should not have to make it cost a special item in our estimates.

Trentham Estate memorandum, 15 December 1916 (notes written in the margin in pencil): 'I think some or many of the subscribers could well afford to give a few shillings each more to meet this. The Trustee's would this time, but not to form a precedent, bear half the cost of interior upkeep. Signed *B.A.P.* 21st December 1916.'

Further notes scribbled at the bottom in pencil:

I find as the result of enquiring that the credit balance sheet shown in last year's statement of accounts to now exhausted, and that the association is entirely without funds.

Benjamin Arnold Prowse was born in 1869 at No. 56 Trentham Road, Longton. Son of Benjamin and Sarah. His mother was born Longton in 1845, but his father was a Cornish man and employed as a schoolmaster locally.

4. Work

Ducal Librarian and Bookbinder

Peter Gilworth was listed as a bookseller at Newcastle in 1676, when he visited Trentham Hall on 8 March to supply six books to Lady Leveson. He had married Elizabeth Clay in 1660. Peter died in Newcastle and was buried there on 20 May 1712. The old established printing and publishing premises at No. 44 High Street, Newcastle, was taken over by David Dilworth in 1848. His father was John Jackson Dilworth, baptised 1786 in Lancashire, and his mother was Ann Wilcockson, baptised in 1788 at Preston. David was apprenticed to his uncle Isaac Wilcockson, who was a tea dealer and newspaper publisher. It was Isaac who helped David to acquire the business at Newcastle.

The business was printing books and broadsheets as early as 1670 with Peter Gilworth, and it prospered under David's Dilworth's leadership – the quality of his books with

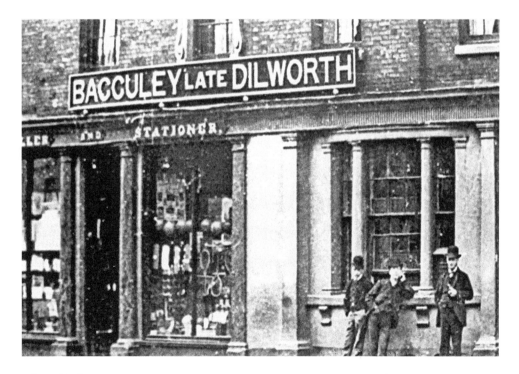

Dilworth's shop.

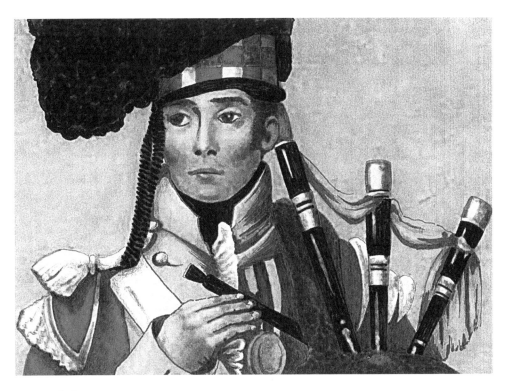

George Clarke.

Trentham Hall terrace.

leather bindings was noteworthy. He had an ingenious mind and invented triangular blotting pad corners to hold the blotting paper flat. Unfortunately, it made no money due to patent fraud.

David, like his sister Mary, was small in stature and described as a 'merry little fellow' who was always cheerful. He married Emma Goodall in April 1855 and had a comfortable town house in Newcastle and one in the countryside near Emma's old home at Whitmore. He employed three men. David retired in 1884 and his son Frederick took over the business.

David and Emma went to live at Low Abbey in Lancashire, Emma dying at Blackpool in 1894. David moved to live at Hillside, Bowgreave near Garstang, after his wife's death. His sister Mary moved to live in Newcastle with him until she married a Quaker named Jonathon Abbatt in 1855 at Calder Bridge Friends Meeting House.

George Thomas Bagguley was born in 1860 and was an apprentice to David Dilworth. He took over the business after the death of David's son Frederick, appearing in trade directories from 1892 to 1940. It is not known if he learned to book bind, but he did employ a bookbinder and bindings signed 'Bagguley' were made at his premises. George was librarian at Trentham Hall and responsible for all book repairs at the library. His leather covers had little more than a linear design, while the patented process, which he invented in 1895, was called the Sutherland Binding after the duchess.

The Estate Pipers

George Clarke (1784–1851) was the first piper employed at Trentham by the 2nd Duke of Sutherland. He was a native of Tongue, on the north coast of Scotland, who fought in the Peninsular War at Vimeiro, Portugal, where he was wounded in both legs but continued to play his pipes as his regiment of 71st Foot, Highland Light Infantry went into battle on 21 August 1808. George was pipe master of his regiment. He was back in Portugal in 1810, but was home by 1815 in time for a piping competition in London. George became piper to the Highland Society of London in 1816, playing regularly at all the meetings, being paid 1 guinea per performance, and from 1824 an annual salary of 24 guineas. Clarke was the most famous piper of the day, not for his piping skills, but for his actions at Vimeiro. He was presented with a specially made set of bagpipes, crafted by Robertson in 1809, by the Highland Society of Scotland, and another new set made by Malcolm Macgregor from the HSL in 1820. A gold medal was presented in 1815, followed by a special cast medal in 1822 for his actions at Vimeiro. From 1829 he was frequently helped out by John Macbeth, who became his successor as Clarke's health began to deteriorate. His salary continued until 1837 but his duties became negligible. In 1838 he returned the pipes and flag together in a small box, with a letter saying 'I am not able to go outdoors, my limbs are very bad.' The situation was relieved by the Duke of Sutherland, who made him his piper at Trentham, again assisted by John Macbeth. George Clarke was issued with his own key to the gates at Trentham Park in 1841. George died in 1851, aged sixty-seven, Macbeth having taken over as the Duke's piper sometime before.

DID YOU KNOW?

Beneath Hem Heath lies a giant underground lake. It is 450 feet below the surface and has a depth of 100 feet. Tollgate Sports Club sank a borehole to reach this lake in 2010 and it was found to be pure spring water, which was used to provide energy to the sports club in an open loop system, providing free heating before being returned to the lake.

Collieries

A borehole was sunk at Newstead in 1896 to establish the location of the coal seams running from Great Fenton Colliery. A shaft was sunk in 1924 and the first sod cut by the Duke of Sutherland. Progress was seriously delayed when a fast-flowing underground stream from the subterranean lake was encountered. This had to be frozen to allow work to carry on.

The winding gear at the new colliery was steam driven with a bank of Lancashire Boilers. No. 2 shaft was sunk in 1950 and took two years to complete, 24 feet in diameter and initially700 yards deep, extending to 1,200 yards later.

Again, an underground stream was encountered which had to be frozen to allow work to continue. At the same time No. 1 shaft was deepened and a concrete tower built over the shaft.

Florence Colliery.

Hem Heath Colliery.

A new style A-frame was built over No. 2 shaft, whose legs measured 5 feet across, one side had a ground mounted electric winding engine and the other side a Koepe electric winding engine. The original steam winding engine at No. 1 shaft was replaced by a tower mounted Koepe electric winding engine directly over the shaft.

Florence Colliery was much older: the pit shaft was commenced in 1872 by the 3rd Duke of Sutherland and named after his daughter Florence. The shaft sinker was Samuel Jones of No. 125 King Street, Fenton. In 1959 there was a fight between two miners at Florence Colliery. One was a black man and the other a Scotsman. This resulted in the black man being fined £5 with £3 12s 9d costs, despite him pleading not guilty. The case against the Scotsman was adjourned because he was away in Scotland.

Kilninian Parish Church

This church stands on the shore of Loch Tuadh and was built in 1754. John Mcphail was baptised here on 5 March 1857. By the time he was seventeen John was working at Duart Castle Gardens as an apprentice gardener under the guidance of John Elder. John Mcphail moved south to Trentham when he completed his training, and it was here he met a young pottery burnisher from Lonsdale Street, Stoke, named Emily Reeves. John married Emily on 23 December 1877 at Copeland Street Congregational Chapel.

It appears that John took his new wife off to County Sligo, Ireland, where their firstborn child died. A second child named Rosina Jane was born there in 1885. In 1888 John returned to Staffordshire where he obtained a position as park superintendent of the newly completed Queen's Park, near Longton. The 1901 census has them living at the

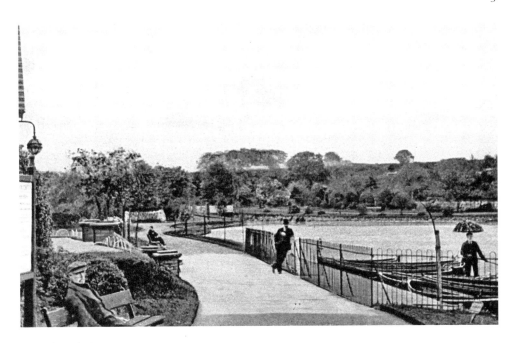

Queen's Park, Longton.

park lodge with Emily's father, aged eighty-three, a retired copper engraver. Emily was buried at Blurton on 8 November 1917, and her husband John on 23 October 1925. Their daughter Rosie became a music teacher and remained a spinster. She died in hospital and was buried at Blurton on 5 February 1932, aged forty-seven.

Thomas Cone and the Alma Pottery Works

The pottery manufactory was built in late 1854 and named after the Battle of Alma, which took place on 20 September 1854 at the start of the Crimean War.

The works was occupied by William Bourne in 1857, manufacturing earthenware. He went into partnership as Till, Bourne & Brown from 1859 to 1860. William Bourne's business ran into trouble and the partnership was dissolved. He was declared bankrupt in 1862.

The factory lay empty for a while until Joseph Middleton and William Hudson set up business there in 1870. They continued until 1889 when Middleton left to start another pot-bank. Hudson continued until 1892 when he also left. Eventually they became established as Hudson & Middleton. That year saw another venture at the Alma Works with Lewis Bentley and Thomas Cone. Thomas Cone continued at Alma Works alone from 1893. His parents Thomas Snr and Maria Coyne were both from County Mayo, Ireland, and left during the hungry forties to try their luck in the potteries.

Thomas Cone appeared to be doing very well by 1901. He had purchased a villa at No. 81 Trentham Road, on the new Florence estate on the outskirts of Longton. This was no ordinary house as it had ornamental lintels over the door and windows.

Alma demolition.

Cone's house, now Dresden House.

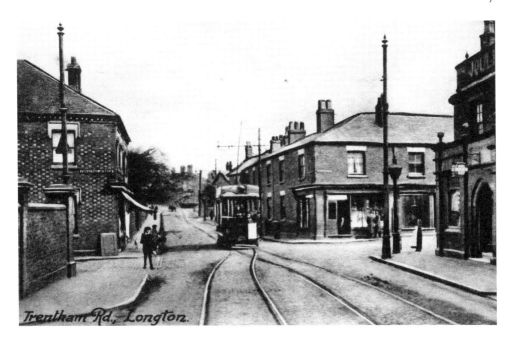

Trentham Road.

By 1911 he had advanced along the road to Stanbrook House, No. 105 Trentham Road. He and Elizabeth had now been married for thirty-six years, having two children, Living with them was granddaughter Alice Margaret and sister-in-law Sarah Susan Sutton, who old Thomas would marry when his wife died. Elizabeth died at Stanbrook House on 16 October 1916. Thomas married his sister-in-law on 3 November 1917 at St Gregory's RC Church in Longton. Thomas died on 28 May 1918 while on holiday in Blackpool. He was buried with his first wife at Longton. The funeral at St Gregory's was at eleven o'clock, with interment at twelve o'clock in the municipal cemetery.

Cromartie House

In 1864 the Trentham Estate office prepared plans for development of the Spratslade area to complement the new estate built at Dresden. The estate was to be called Florence after the Duke of Sutherland's daughter. The building plots were sold with a ninety-nine-year lease and not freehold as Dresden had been.

William Copestake purchased plot No. 28 fronting Belgrave Road in 1867 and built a large detached house on a corner plot siding onto Cromartie Street. William was a pottery manufacturer born in Fenton. He married Ann Hilditch. They went to live in Paradise Street, Edensor, overlooking the Daisybank marlhole in the poorest part of Longton. They had moved to Sutherland Road by 1841. William was listed as a china manufacturer at No. 51 High Street, Longton.

The 1871 census sees him in his new mansion aged sixty-one with his wife, Ann, and Sarah Hammersley, his widowed sister-in-law aged fifty-four.

The local paper recorded William's death at his home on 6 July 1880 on a Monday. The deceased gentleman was highly respected by a large circle of friends around the district. and up to the time of his death carried on an old established china business in High Street, Longton, and recently under the name of William Copestake and John Allen, a dissolution having occurred recently of the partnership. The business was being carried on under the style of Copestake & Son. The deceased was about seventy years old.

Cromartie House was sold to Henry Mountford Williamson, another pottery manufacturer. He was born on 23 October 1827 at Union Street, Hanley, to humble parents. He served his apprenticeship at Brownfields of Cobridge, and by 1851 Henry, aged twenty-three, was living with his wife Frances at Hope Street, Hanley, where he was a china printer.

Ten years later he had moved to Mollart Street where he was now a gilder of china and his wife was a burnisher. He commenced his life with little more than those advantages with which he had been endowed by nature. His natural gifts were great. Not only did he have a robust physique, but also had an alert and discriminating mind, and was able to express himself in pungent and appropriate speech. He was also gifted with humour and every company to which he was admitted was brightened by his general presence. He also had a deeply sympathetic and emotional nature, and not seldom were his eyes suffused with tears in the presence of sorrow or distress. His sympathy coloured his whole life, for while devoting himself to business, but there was never a time when he was so engrossed in business that he had no regard for the well-being of the community in which he lived.

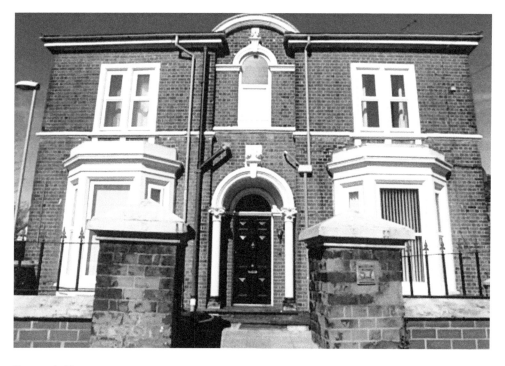

Cromartie House.

The stables.

Around 1867 he moved to Longton where he started a business. After a stubborn fight he built up a large china manufacturing concern at Heathcote Road called the Bridge Works. He died at Cromartie House on Wednesday 31 July 1907; he had been ailing for a long time and had suffered pain considerably, having been in a prostrate position for the last two weeks of his life. Towards the end his heart was affected. He had been approaching his eightieth birthday when he passed away. The funeral took place on Saturday afternoon and he was buried in the family vault at Longton.

5. The Law

Bread Rations

Hamlet Parker Embrey's father Godwin Embrey was an apprentice blacksmith at Hem Heath Smithy before becoming a colliery smith. Godwin also ran Fenton Post Office, which had a small bread oven at the rear. The new model bakery was run by two of his sons named Godwin Goodwin and Lawrence, the other son Hamlet had King Street sawmills from where he conducted a building business.

Wartime regulations caused Hamlet, Godwin Goodwin and Lawrence Embrey to be fined at Fenton Court in 1919 as G. Embrey bakers of King Street, Fenton. They were summoned by weights and measures inspectors who saw a van man delivering thirty loaves of bread to Oakhill. Examination showed the bread to be fresh and soft. They spoke to Hamlet Embrey about the matter, who said certain firms in the Potteries were delivering new bread and canvassing for orders guaranteeing fresh bread. Because Embrey's would not supply fresh bread, the sales were going down. In the last six months the sales had gone down to 12,000 loaves per day, and he attributed 5,000 of the loss to other bakeries supplying new bread. He said this particular incident was not deliberate; Embrey's had run out of bread on Saturday and had to make up supplies for the earliest Monday morning deliveries. People were clamouring for new bread and a great number of people were supplying it. Mr Embrey stated 'there is no fiddling', which caused laughter in the court. The stipend said it was impossible to visit every shop and stop every delivery van, but he was glad Mr Embrey had made this statement in court. It was very unfair for certain bakers to profit by committing breaches of the law. In the circumstances, the fine would be £10 with witness's allowance.

Bread was not rationed during the war but steps were taken to reduce consumption. The government ordered that bread was not to be sold until it was twelve hours old. Strangely, it was also against the law to buy a pint of beer for other people.

Embrey's.

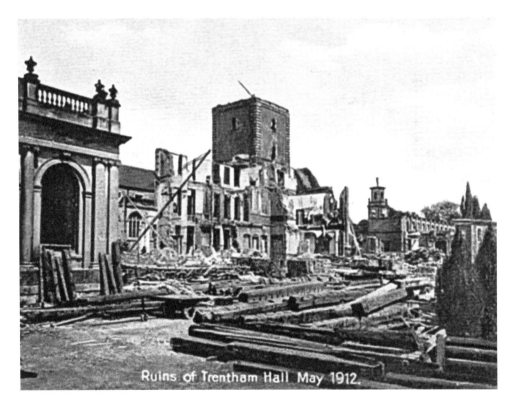

Hall demolition.

Hamlet Embrey's house.

Wartime Regulations

A Dresden butcher was summoned in 1919:

Before the Potteries Stipendiary, today Mr. Frederick William Riley, butcher, of 108 Trentham Road, Dresden, was summoned for exceeding the maximum price of mutton in contravention of the meat retail prices. On 10 May the Divisional Food Officer called at Mr. Riley's shop and spoke to him with regard to certain meat orders made up in the shop and asked to see the meat weighed. One piece to the order of Mrs. T. P. Hulse, was a shoulder of mutton, and found to weigh 3lb 7oz with the price on the ticket at 6s 2d. The proper price was 1s 5d per pound, and the total charge should be 5s 1d. Mrs. Hulse said that her order on the day in question was for 1lb of shin beef and half a shoulder of mutton. Her order was always entered in her account book, and the order for this particular transaction was beef 1s 4d and mutton 4s 10d. She had traded at Mr. Riley's shop for 30 years and it was her custom to weigh all the meat for the purpose of her accounts book. She had never known Mr. Riley charge too much. The defendant said he was at the scales when the meat was weighed and he called out to his wife who made the ticket out. She unfortunately had entered mutton 6s 2d, instead of mutton and shin beef 6s 2s. He himself had entered mutton and shin beef 6s 2d in Mrs. Hulse's book. There were many customers in the shop at the time of purchase and by an oversight the beef was not mentioned on the ticket.

The second summons alleged an overcharge in respect of mutton sold to Mr. Ray. Brough. Inspector Hamnett gave evidence as to visiting Riley's shop and seeing a leg of mutton on which a ticket had been placed bearing the price 14s 4s. He said the leg was

weighed at 8lb 7oz and the proper charge should have been 13s 1d. The witness admitted that in another instance a piece of meat was priced at 12s 4d when it should have been 13s 1d. Mr. Breton said that Riley had a computing scales that showed the price and weight of the meat. Riley's assistant, who had just come out of the army, was not used to the scales and must have looked at the wrong indicator. In one instance he had made a mistake against the purchaser, and in another he made a mistake against his employer.

The Stipendiary held that there was a reasonable doubt in regard to the first summons and the case was dismissed. The second summons he took to be a simple mistake, and the fine was £10.

Farewell Entertainment

To the Patients and Staff of the Stoke War Hospital.
IN THE TRENTHAM GARDENS
On Wednesday Next, May 28th 1919
N. S. MILITARY BAND.
(Bandmaster C. Osbaldeston) will play selections from 3 until 7.
DANCING UNTIL 9.30.
Tea Rooms open for convenience of the general public.
Price of Admission to General Public as usual.
COME AND BID THE BOYS AND STAFF A REAL GOOD-BY-EE.

War Hospital.

Ward 'A'.

Poachers on the Duke of Sutherland Estates

In September 1859 three men were charged in pursuit of game. James Boulton and Henry Wright, along with William Henshaw, appeared at Longton Police Courts on Monday charged with poaching in pursuit of game on the Duke of Sutherland's land, and also with threatening to shoot William Simcox, assistant gamekeeper to the Duke of Sutherland.

The offence occurred at a quarter to four on Sunday morning. If it would have happened half an hour earlier, the charge would have been the much more serious crime of night-time poaching, especially as the men carried firearms with them, for which they could have been sentenced to transportation.

The defendants were employed by Wright's, contractors for the North Staffordshire Railway and in receipt of good wages, so there was no excuse for what they were doing. William Simcox stated that he was on duty on Sunday, near to Trentham railway station, when he saw the three men in Earl Granville's meadow with guns. He watched them out of the meadow and saw them going along the railway near to a field belonging to Mr Davenport at the Blurton Waste Farm. Boulton and Henshaw stood with their guns to their shoulders, while Boulton imitated the cry of a Leveret to attract the hares towards them. William Simcox was then standing on the bridge and he called out to ask what they were doing.

He walked along the rails to within 20 yards of them, when Boulton and Henshaw pointed their guns at him, and said if he came any nearer it would be the worse for him. They walked on and Simcox made an attempt to overtake them. When they turned around again and pointed their guns at him, Henshaw saying that they had given warning to him

and if he came close it would be the worse for him and his dog too. They were not going to be taken by one man. The three men entered into a plantation and Simcox traced them to California, near Stoke,

In the police court, James Boulton had shaved off his whiskers to disguise his appearance, but the gamekeeper said he definitely recognised him and it was the same man.

After listening carefully to the evidence, the magistrates said the case was proven, and William Henshaw was fined 20s, plus costs, and ordered to keep the peace for twelve months. He was also ordered to find a surety of £20 or one month imprisonment. James Boulton was fined the full penalty allowed of 40s, plus costs, and ordered to keep the peace for six months and £20 surety or face two months imprisonment. Wright was dealt with in a more lenient manner and fined 5s, plus costs.

Cockfighting at Trentham

Cockfighting, or as its devotees invariably called it 'cocking', was an ancient sport and Staffordshire had led the way. John Wesley preached in Richard Myatt's yard at the Foley, Longton, in 1790. He spoke about cockfighting and goose riding (sometimes called goose pulling) being an evil sport. Goose pulling is too barbaric to commit to paper.

Cocking was abolished by law in 1849 but lingered on openly until the sport became too risky. The sport was the cause of much brutality and fraud. One case that was written about involved a man putting arsenic in the drinking water of his competitor's game birds.

James Tunstall, born in Manchester, was living at Fenton with his wife Sarah, born in Leek, and son's James, William Arthur and Frederick G., all born Fenton, in 1871. The second son, William A., married Sarah Alice Jackson in 1885. William became a shorthand clerk on the railway.

He was a well-known North Staffordshire cockfighting attendee, and got summoned more than once for taking his fighting cocks to events around the district and beyond. He went to live at the White House in High Street, Hanford, but moved to Ewelme' Trentham, sometime after 1911. It was from here he was caught cockfighting in the courtyard of the then demolished Trentham Hall. This did not deter William, who was caught again 17 July 1928, at Old Buckenham Stud Farm, Norfolk. The contest took place inside a horsebox so as not to be seen, but the police had been observing the farm for some time and raided the occasion, confiscating the cocks in the arena. Eighteen people were arrested and sixteen were each fined the sum of £10.

William died at his Trentham home on 21 August 1932, and his funeral was at Trentham followed by interment in the mausoleum graveyard. He was a prominent Freemason and a past Provincial Grand Registrar of Staffordshire.

As a sportsman he gained national reputation, being a well-known athlete and member of the Staffordshire Sporting Club. At the conclusion of the service at the graveside the Freemasons filed past and dropped their customary sprays of acacia flowers.

His son Eric Moss Tunstall was a well-known North Staffs artist, a gifted portrait and landscape artist who is responsible for many of the signs outside pubs in the district.

Staffordshire jug.

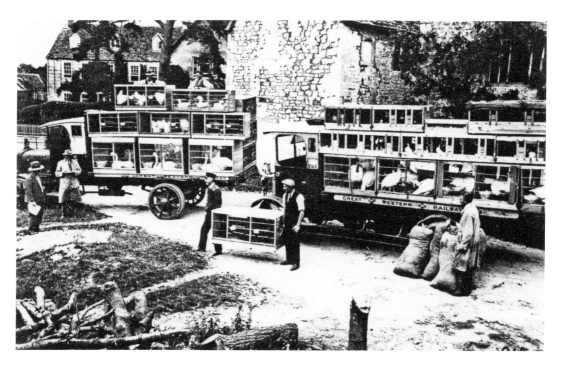

Game birds.

Stable yard, Trentham.

Red Gate Inn

There was a building on Trentham Road, Spratslade, from the eighteenth century, which became a beerhouse notorious for its brutality in blood sports during Trentham wakes, taking the name of the Red Gate Inn. The tenant combined beer sales with farming on fields he rented across the road. Samuel Taylor wrote in 1888 recalling his childhood visits:

> There were assembled the lords of creation as howling demons, with dogs less brutal than their owners. A bull was to be baited and the excitement was at fever pitch. A great ruffian named Bellat Leads the bull out amid great applause, men howling, dogs barking, and youngsters screaming at the top of their pipes. The bull is made fast to the stake and three dogs are let loose on the bull. One after the other they make for the bull's nose but are soon high in the air. The third and largest dog succeeds in seizing the bull by the nose to which he hangs, never to let go until he brings away a piece of flesh. The bull is frantic with pain, he tears around the ring mad and furious, bellowing and roaring frightfully. Suddenly the alarm is given, he is loose, and soon trampling over men, children, and all the rabble. Having overturned everything and everybody he makes his way back to the stable.
>
> During Trentham Wakes we are treated to a prize fight between two local champions named Moses Edwards, a pot seller, and Charlie Hollins, a collier. The smaller of the two men came out of the fight with little harm, while the big man was blind in both eyes and one arm so damaged as to be quite useless.

Bull-baiting.

Besides cock fighting, bear baiting and badger drawing, there was a fight between two Mastiff dogs of enormous size. This was a fearful sight and lasted a long time, the spectators gloating over it with savage glee. At length, one dog was dead, in a short time the dead animal began to swell until it was twice its natural size.

The Duke of Sutherland closed it down and renamed it Sutherland Cottage.

Local Girls and American Soldiers

In June 1944, a sixteen-year-old Meir girl appeared in the juvenile court at Fenton with a supervision order. On 17 May certain allegations were made against her in respect of a roadside café called the Darlaston Café at Tittensor. Superintendent H. Edge of Longton said the girl had been away from home for twelve days and had caused considerable worry to her parents. The girl had been in the company of American soldiers and has several times been reported missing by her parents, who were unable to control her.

The girl stated that she and other girls, who usually number around eight, went to the cafe at 10.30, staying until 3.30 in the morning. The girls often slept in the room until the early hours, when they left to have a walk around. She stated that the café owner did not know that they slept there. 'We collect and pay for our own food,' she said. Superintendent Edge said he had taken this and other cases to the American army authorities, but their answer was that they could not keep the girls away from the American troops.

Potteries Stipendiary Magistrate said it was incredible that the owner of the café was not aware of what was going on. They ignored or were indifferent to the fact that the girls

were using the café until the early hours as a waiting room. The girl was committed to an approved school.

Stolen Bicycle

A red-coloured lorry was stopped at Trentham after a police officer shone his torch on the passing load. He saw a bicycle on the top of a high load which had been reported missing, stolen from outside The Kozy Cafe at Brocton. Police Constable Simmonds was informed that the driver, Francis Booth Vickers, had paid a coloured American soldier £2 for it, and he knew it would be trouble. The bicycle was valued at £7 10s, and Vickers and his assistant were each fined £20 with costs of 17s 6d.

Darlaston Café.

Interior of
Darlaston Café.

Monument Café.

Tipsy Toffs at the Trentham Hotel

Monday 9 April 1906. At the Hanley County Police Courts this Monday morning, Mr. John Inslip, licensee of the Trentham Hotel appeared to answer ten summonses charging him with offences against the licensing acts There were also other summonses against other individuals in respect of the same case. Mr. Inslip was charged with allowing drink to be consumed during prohibited hours on 22 March. On the evening in question there was a Volunteer Dinner at the Trentham Hotel, under the management of the defendant, Sergeant Murray, the police officer stationed at Trentham arrived at the house around 9.50 p.m. and remained there from that time until 10.20 p.m. During that time people were passing in and out of the Inn, and in consequence Murray went into the Inn and found in a room being used as a dining room, a large group of people including many volunteers. He called the defendant's attention to this fact, and he replied that he had not served drink since ten o'clock and that they must go. He was not charged with selling alcohol after ten o'clock. At the time during Sergeant Murray was in the house, people still had drink in front of them, and the charge was to allow intoxicating liquid to be consumed after hours. Sergeant Murray said he was outside the house on 22 March during the hours of 9.50 p.m. and 10.20 p.m. and during that time people were going into the premises, he went in and asked the landlord if he had an extension to drinking hours, and the landlord replied that he had not, but he had not supplied any liquor since ten o'clock. He suggested that the Sergeant should show himself in the dining room and shift them.

The witness said he did so and found about 100 people, some having drink before them. There were officers, non-commissioned officers and privates, together with contributors to the prize money and members of the Morris Tube Club. The only place

where liquor could be served was at the bar, which was open at 10.20 p.m. The defendant was charged with 'allowing' the action should be with the prosecution to prove that the defendant knew drink was being consumed and that he had allowed it to be done. Such permission had not been given. It was pointed out that a considerable amount of force would be necessary to compel the men to leave the premises before drinking up [laughter in court]. The landlord appealed to the men, reminding them that he had no extension to drinking hours and even invited the Sergeant to go in and show himself in order to hurry them away. The fact that the landlord did not collect the un-emptied glasses containing the liquor after closing time was evidence that he allowed the drink to be consumed. Captain C. E. Boote, an officer of the regiment dining at the hotel on the night in question, said that before ten o'clock Mr. Wedgewood, one of the officers, called for a final round of drinks to be supplied, but the landlord refused to supply them as it was getting near to closing time. The volunteer replied 'then supply no more drink, and we shall go as soon as ever this song is finished'. The landlord asked the company to go and the police came outside. He said, smiling, that he was sorry that the custom of inviting the police had not been done, as in previous years, and as an apology he offered the police some cigars, which they accepted in a friendly manner [laughter in court]. Mr. Breton asked the Captain if the men at the dinner were under his charge, and did not the licensee approach you and say he would be committing an offence if he was open after the permitted hours, and asked you to use your authority to tell them to go, what would have been the result if you had? Captain Boote replied 'I could not say until I tried' [laughter in court].

Did you not think as commanding officer of the company that your authority would have immediately had the effect of getting them outside? The Captain said it would have taken five to ten minutes. The landlord asked them to go, certainly once, and it might have been more times.

They asked to make it clear that the prosecution was not being undertaken because the police were not invited. They said it was only a joke, they only brought out the fact to prove that they were all on friendly terms and good humoured.

Mr. C. D. Bradwell, J.P. of Chester, deposed that he was staying at the Trentham Hotel and that he was at the premises at closing time on the night in question. He heard the landlord call 'time' at ten o'clock.

Mr. Abraham Fielding, of the Railway Pottery, Stoke, addressing the court, said that he felt very strongly with regard to this case. He was a subscriber to the Volunteer Prize Fund, and had been particularly pressed by the officers to be present that night. He did not want to go, but under pressure he consented. It was the first time he had been this year. That he was committing a breach of the law never entered his head: it was actions such as this which brought the police and the law into downright contempt. The Volunteer corps was composed of men who had in some cases to go three miles to drill – men who gave their time and services for nothing. On this occasion they were supported at inconvenience and expense by one or two friends, and then they were pounced on like this! The police Sergeant ought to have turned a blind eye. If he had, no one would have blamed him. Neither would his superior. No doubt the officer had done his duty, but there were cases where a little broad-mindedness should be used. It reflected no credit on the police.

Trentham Hotel.

Trentham Hotel.

The sign
outside
Trentham
Hotel.

Mr. Fielding added that he and others of the defendants would not have been at the
hotel for so long had it not been for the fact that when Mr. Inslip called attention to the
time, Captain Boote said that they would have 'God Save the King', and then go. There
were about 120 or 130 men there and how was it possible to get them all out in two or
three minutes? It was the singing of 'God Save the King' which kept them longer than
they would otherwise have been there. Mr. Macrory said he would be sorry to put his
offence down to the King [laughter in court]. There would be a conviction in each case,
and defendants would be fined 2s 6s.

6. Hard Times in the Victorian Era

The Gamekeeper

The sad death of a Trentham gamekeeper is described in the *Sentinel* on 1 January 1888:

An inquest was held at the Bull's Head Inn, Hanford, on Saturday before Mr Booth, coroner, on the body of George Strudwick, who as reported was run over by a wagon loaded with straw belonging to Mr Daniel of Stoke, in the fog near to Trentham on Friday night last. The deceased had been head gamekeeper on the Duke of Sutherland's estate

at Trentham for the last 19 years. He called on Mr James Bill, farmer of Trent Vale, about 5.15 p.m. and left about 25 minutes later. The accident occurred about 6.15 p.m. at a point nearly opposite the brickyard towards Trentham. He states that it was so dark and the fog so thick at the time, that he was obliged not only to lead the horse, but to walk in the track worn by cart wheels in order to guide himself aright. The first intimation he had of an accident was the horse giving a snatch as if the wheels of the waggon had run against something. He immediately stopped and called out to the driver of the hind waggon to do likewise. They struck a match and found the body of the deceased. It was so dark that it would have been impossible for witness to have seen him, the deceased had been walking in the centre of the road, as was his custom, and thinking himself out of the way of waggons, was caught by the shafts, was knocked on his back and afterwards run over by one wheel.

The jury after a short deliberation recorded a verdict of accidental death.

The Trentham Tragedy, 1894

Double Murder by a Mother.

The princely seat of the Dukes of Trentham, so happily associated at holiday times with health giving pleasure and gaiety, has this Whitsuntide been overshadowed by a tragedy. Yesterday afternoon the bodies of a woman and two young children were found in the lake, and the circumstances point only too conclusively to the fatalities being the result of an act of criminality on the part of the woman. The discovery was made by a passer-by about half past two o'clock in the afternoon. He was passing through the wooded portion of the park near the lake when he noticed a perambulator standing on the borders, it stood about fifteen yards from the lake unoccupied and unattended, a fact which struck the man as somewhat peculiar. In glancing round he discovered what appeared to be a body floating in the lake, and a closer inspection revealed the fact that there were two. They were those of two children, and they lay in about two feet of water, not far from the margin of the lake. Without waiting to search further, the man, who was naturally much perturbed, ran off to get assistance, and give information at the lodge at the park entrance, which is about a quarter of a mile distant from the fatal spot. Mr. Peter Blair, head-gardener, and a number of estate servants hurried to the place-known locally as Spring Valley, and it was not until then that the full horror of the discovery was apparent.

It was clearly no accident. Nearby the corpses of her children the body of the mother was found.

All were dead beyond doubt. The lifeless bodies were removed to the Trentham Hotel, there to await an inquest. Subsequent enquiries proved that the woman was Hannah Edwards, wife of a collier, living at Boothen, Stoke, and her two children were named Ernest and Olive, aged respectively three years and ten months.

The scene of the tragedy is one of the prettiest spots in Trentham Wood, the scenery of which is just at this time of year looking at its best. Footmarks and the impressions of a perambulator make it fairly clear that the woman and her children went through the swing gate at the Trentham entrance to the wood, and after

proceeding down the main drive for about 400 yards, turned to the left, down the first of the paths marked private and known as Green Walk. Fifty yards along this path would bring her to the edge of the lake. The view from this spot is one of the most charming in Trentham. All around the ground is covered in bluebells, moss and ferns, whilst across the lake on the opposite side the rich foliage of the trees is abundant. On the right is the large island, which has recently been set in order and improved in appearance by the Dukes gardeners, and on the left is a small island, whilst away in the distance is the full view of the hall and picturesque Italian gardens. The depth of the water at this point is only about two feet at the side, which is approached by a grassy slope.

From all indications, it seems evident that the woman walked deliberately into the water, for there is not the slightest sign of any struggle at this spot. She would have to go several yards into the water before she could get out of her depth, and the theory is that she carried her children in her arms and held them until the end. All the bodies were found close together, only a few yards separating them. When discovered the bodies were floating, and it is supposed they had only been in the water for a short time. No tragedy of so distressing a character has occurred at Trentham for many years.

The only element of mystery in what is unfortunately a rather common-place domestic tragedy lies in the conduct of the man who made the discovery. He was walking in the woods in the company of a young lady companion when he noticed the empty perambulator standing unattended on the gravel walk. A glance at the lake revealed the bodies in the water close to the bank. No attempt appears to have been made to get them out, or to ascertain if life remained. Instead, the man went to the gateway leading from the park to the woods, and there acquainted an old man named Spooner – who occupies his time in opening the gate for vehicles – with what he had seen.

Spooner advised him to inform the people at the hall of what had occurred, and the man who was well dressed, and of respectable appearance, at once proceeded to the hall yard and told the man in-charge of the office of what he had seen. The alarm was raised, helpers not wanting, Mr. Peter Blair, the head gardener, with several others, proceeded to the spot indicated, and found the sad intelligence was correct. The bodies were floating close together, within an area of a few yards, in shallow water. The depth in fact was so little that one of the party was able to wade out to bring them back to the bank. In the mean time a van had been brought to the place, and the bodies were conveyed in it to Trentham Hotel, where they were placed in an outhouse to await the inquest.

Naturally the discovery aroused much excitement in the village, whose inhabitants are fortunately rarely brought face to face with such a tragedy. Amongst the houses where it was discussed was that occupied by Mr. Tom Banks, the estate plumber, who had helped to get the bodies out of the water. Curiously enough a couple of lady friends were having tea with him, and on describing the woman, the children, and the perambulator, they at once remembered seeing Mrs. Edwards, who lived in

the same area of Boothen as themselves, in Trentham during the day, and knowing what they did of her home life, they jumped to the conclusion that she must be the ill-fated woman.

They were taken to Trentham Hotel and verified their misgivings.

Sergeant Hughes, who has in-charge of the Trentham district was at Longton Park Fete on special duty when the dreadful act was committed. Mr. Dorree of the hotel, very kindly dispatched a trap to fetch him. At Longton, singularly enough, the Sergeant met the husband of the woman, who at that time had not been identified, and spoke to the officer, who asked him where he was living.

The man replied "I don't know", probably not caring that the police should be too well acquainted with his address. This is accounted for by the fact that a few years ago when living at Hanford, Edwards was concerned in a poaching and sheep worrying expedition at Trentham, which had unpleasant results for his companions.

The police are directing their energies to tracing the movements of the deceased before the fatal occurrence. From what they can gather it appears that when Mrs. Edwards reached home on Monday night she was in a state of complete trepidation and dared not go to bed.

Edwards himself seems to have gone upstairs leaving his wife below. What passed between them will probably never be known. His conduct however does not appear to have been reassuring, for towards three o'clock in the morning Mrs. Edwards called a neighbour, Mrs. Kelly, to stay with her until the day had begun. After leaving her home the woman set off along the canal side in the direction of Hanford, where she had lived, and where she was recognised and accosted by some of her old friends. She was next noticed about twelve o'clock in the vicinity of the reservoir in the park. Whether she was contemplating suicide cannot be said. The water here is railed off, and it would have been a feat of some difficulty as the rails are of a considerable height.

This as far as it is at present known, was the last occasion on which the deceased mother and her two children were seen alive. It is surmised that the woman proceeded along the main carriage drive and through the gateway, shortly after turning sharply to the left and down to the water edge. Traces of the perambulator wheels and the imprints of the woman's boots, which had been newly soled, were plainly visible yesterday in the soft soil of the rarely trodden path.

The bodies lie side by side in the carriage house at Trentham Hotel, the woman having the youngest child on her right and the youngest on her left. They present a pitiful spectacle.

The unhappy woman who sought release from a state which had little but terror for her, was married to the man who promised to love and cherish her about six years ago. For some time, they lived at Hanford, subsequently moving to the borough of Stoke, her age was twenty-eight. They have had three children, the two who shared the fate of their distracted mother, and a girl who reached the age of about four years, and died almost simultaneously with the birth of the youngest child. The poor little thing was ill for a long time from tumour on the heart.

Left: A Trentham guidebook.

Below: Trentham Lake.

The lake in 1900.

Cholera Victims at Blurton

One family who may have been cholera victims were Joseph Blunt of Merrial Street, Newcastle, his wife Sarah Margaretta and their daughter Alice. Joseph was born in July 1806 and baptised at Blurton. He was the son of John Blunt, perpetual curate of Blurton, and his second wife Mary Ford, whom he married at Blurton in 1805. John was also vicar at Lilleshall from 1815 to 1843, and headmaster of Newcastle Grammar School. Surgeon Joseph had married Sarah Margaretta in 1840 and their first child was Hugh Ford Blunt, baptised at St Giles', Newcastle, in 1841.

Sadly, the little boy died aged five months and was buried at his grandfather's church at Blurton. Two daughters, Mary Louisa and Ellen, were baptised at Newcastle in 1844. Alice was next in October 1845 and then Elizabeth in 1847. Cholera was sweeping through the town and Joseph's wife Sarah Margaretta was the next to join her son at Blurton in December 1847. Baby Alice followed seven months later in July 1848. Heartbroken, Joseph was the last to enter the brick-lined vault after a lingering illness, in September 1849, aged forty-nine.

A disaster in 2012 struck the vault where the Blunt family had lain in peace for 163 years. Days of heavy rain had soaked Blurton Church graveyard, until it could take no more. The ground collapsed taking the tombstone tumbling into the pit and disturbing their peace.

The church officials reported it to the authorities who carefully filled in the void the next day. Was it a cholera grave? The authorities certainly seemed to think so.

There was a carpet slipper maker named Joseph Myatt living Rose Cottage, No. 33 Barlaston Old Road. He employed five men. Joseph had nine children, the second youngest of which was Joseph Jr, who was born in 1856 at the cottage. Young Joseph married a domestic servant named Hannah Key, from Dresden, at Blurton Church on Christmas Day 1877. He obtained work as a sexton at Dresden Church on Red Bank. This was where tragedy struck the family. Hannah made Joseph's breakfast and saw him off to work as usual. At 8.30 a.m. she went upstairs with the six-month-old baby and put them to bed. After coming downstairs she turned and went back to the bedroom; nothing was heard from her for some time. Her seven-year-old son James went to check on his mother and found her lying in a pool of blood with a knife beside her body. Her throat had been deeply cut and was practically severed from her body. She had been in a low state for some time and had committed suicide. Hannah was buried in unconsecrated ground in 1892 at Longton Cemetery. Things came to a head when neighbours became concerned for the children's welfare. Sergeant Leese visited the house at dinner time and saw five of the children in a dirty, filthy state. They were badly clothed and had scarcely any shoes on their feet. They seemed about half fed. The heads of three of the children were in a shocking state: very sore and with hair matted to their skin. The youngest child was nothing but skin and bone, and on their shoulder was a wound caused by a burn that had not been dressed or attended to. The sergeant said he knew Joseph and that he took a lot of drink at the weekend since his wife had died. The sergeant went upstairs and found the children's bed all wet and in a shocking state the stench was bad enough to cause a fever. There was nothing in the house except two old jackets. The children were found sitting around a few cinders in the fireplace and there was not a bit of coal in the house. The only food was a small dry crust so the policeman went to a neighbour for a cup of milk, which he gave to the youngest child, who gulped it down thirstily. Joseph returned home in a drunken state

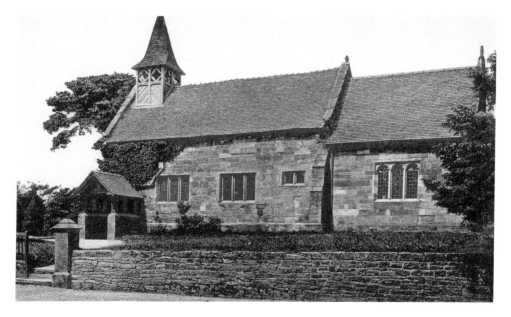

Blurton Church.

Right: Joseph Myatt.

Below: Rose Cottage.

soon after. Sergeant Beech visited and found the beds alive with vermin. Joseph was found guilty at Longton Police Courts of child neglect and sentenced to three months in Stafford Goal with hard labour. The children were taken into care at Stone. Joseph was released from prison in 1893 and immediately set about retrieving his children from Stone Workhouse. He was allowed to take Clara, James and Sarah on 2 May 1893 but had to reapply for the others. He was allowed to take Joseph and Ada on 25 July 1893. Ernest was not allowed home until 18 September 1894.

Joseph went to live at Sandford Hill and met an unmarried mother of five children, all born in the workhouse. It seems that Gertrude Boulton was a very friendly lady.

Joseph's first child with his new wife Gertrude was Leveson, born in 1896, followed by seven more. The children were christened Boulton-Myatt because the old couple did not marry until 1915, when all the children had been born. Joseph obtained work at Longton Cemetery as a gardener/grave digger, which seems ironic as he was buried there in 1926 after catching bronchitis.

Fatal Shooting, April 1907

Man Found Shot at the Dunrobin Hotel, Florence.

Early this morning a shocking tragedy occurred at the Dunrobin Hotel. A young man named Ernest Head Phillips was found shot in the yard lavatory under circumstances pointing to suicide. The deceased man was 32 years old and had a wife and two children. He had been working as a contractor on the Sneyd Brickworks and had until recently lived in Burslem. Latterly he had stayed with relatives in Victoria Road, Fenton, but on Tuesday he had spent the night with his wife and children at the residence of his wife's mother, Nurse Spencer, in Alberta Street, Florence.

Today he was to leave Longton at an early hour, accompanied as far as Crewe by his wife; and sail from Liverpool to America this afternoon. It had been arranged that his wife should follow at a later date when he had settled in his new sphere. In readiness for the journey, the deceased's luggage was packed and the deceased rose at early hours this morning. He kissed his children as they lay sleeping in their beds, and getting downstairs he said he would just walk Down the street as breakfast was being prepared. He accordingly left the house, and it appears he called at the Dunrobin Hotel about a quarter past six and was served with refreshments by the barman Fred. Walker. After he had been on the premises for a few minutes, he asked the way to the lavatory, and Walker directed him to the premises at the rear of the hotel. A short time later the bowling green attendant heard an unusual noise in the direction of the toilets, and a servant who was passing the door heard a groan from inside. The barman went to the toilets about a quarter to seven and opened the door with some difficulty as the body of the deceased was prone on the floor and his feet were against the door. Phillips appeared dead, and as though he had succumbed to a fit.

The police were at once informed by telephone and Police Constable Hill was soon at the hotel. Whilst the Sergeant was removing the body, a revolver fell from the deceased's coat. One of the chambers had been discharged and an examination showed that Phillips had been shot through the heart, death appeared to be instantaneous.

Dunrobin Hotel Stone Rd — Longton

Above: Dunrobin Hotel.

Right: Dunrobin Castle.

White Star Line advertisement.

Fatal Trap Accident

A newspaper account from Sunday 28 October 1878 states:

On Friday evening Mr. James Steele died from his injuries received, compound fracture of the thigh and internal injuries.

William Day Kirkby, cashier of Trentham, said that the accident occurred on Tuesday night about seven o'clock. He had been to Stone with William Jones who drove the trap. The deceased did not go with him but the witness saw him at Stone. They were driving a dog cart and they left Stone between five and six o'clock and the deceased came back with them. They approached the witness's house, when about 100 yards from it, the trap went over a stone at the corner of the road. It was supposed that the trap had come into contact with it. The witness had known several people to be thrown out of traps by coming into contact with the stone. On being questioned by the jury, the witness said the driver was quite sober.

William Jones, groom to the Duke of Sutherland, said he drove Mr. Kirkby to Stone, he corroborated the evidence. Questioned as to the cause of the accident, he said the trap had come into contact with a large stone at the gate to Mr. Kirkby's house, it had thrown all three from the trap and the witness was seriously hurt.

The Café Monica, Trentham.

Steele's house.

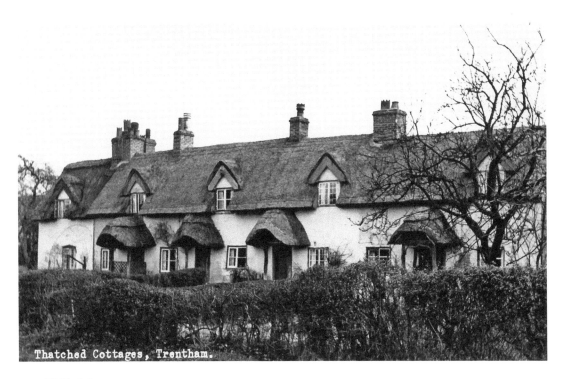

Thatched Cottages, Trentham.

Kirkby's house.

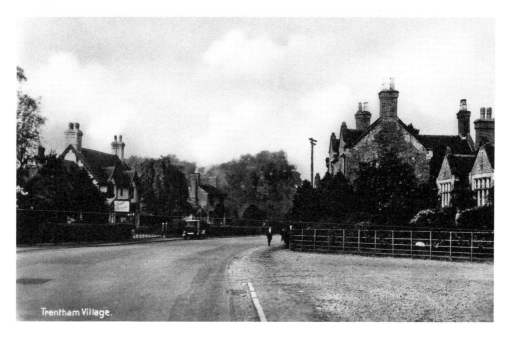

Trentham Village.

Stone Road, Trentham.